IMAGES
of America

ST. MATTHEWS

GREETINGS FROM ST. MATTHEWS. This postcard is typical of "greetings from" cards that were popular between 1905 and 1920. Some were printed, while others, like this one, utilized a generic design and left space for the sender to write in the name of the city or town. (Authors' collection.)

ON THE COVER: **BEARGRASS CHRISTIAN CHURCH YOUTH CAR WASH.** Every youth group in St. Matthews has sponsored (and continues to sponsor) a car wash like this one at Beargrass Christian Church. In 1959, the youth program at Beargrass was in high gear with a revised Sunday school program, boys' basketball teams, an expanded Scouting program, and the completion of a youth lounge. (Courtesy of Beargrass Christian Church.)

IMAGES
of America

St. Matthews

John E. Findling and Tom Morton

ARCADIA
PUBLISHING

Published by Arcadia Publishing
Charleston, South Carolina

Printed in the United States of America

Library of Congress Control Number: 2015941348

For all general information, please contact Arcadia Publishing:
Telephone 843-853-2070
Fax 843-853-0044
E-mail sales@arcadiapublishing.com
For customer service and orders:
Toll-Free 1-888-313-2665

Visit us on the Internet at www.arcadiapublishing.com

Tom dedicates this book to KELSTKMNLCCJ: they know who they are;
John dedicates this book to the memory of Joe Cole and Larry Maurer.

CONTENTS

ACKNOWLEDGMENTS

This book could not have been completed without the very generous help from many individuals and organizations. David Morgan of the Beargrass-St. Matthews Historical Society permitted us to use images from its archives, and Ann Rockwell and Dustin Strong of the St. Matthews Eline Memorial Library gave us a place to work and meet with local people who had photographs and stories to share. Most of the churches in St. Matthews likewise shared their photographs with us, as did the Sam Swope Auto Group and the St. Matthews Chamber of Commerce. Mary Margaret Bell of the Jefferson County Public School archives led us to information about the public elementary and high schools in the community, and Barbara Mullen, archivist at Trinity High School, graciously permitted us to scan images. Jamie Dumstorf at Waggener High School opened the school's archives for us. Other individuals in St. Matthews who took the time to find and lend us photographs from their families' past include Sidney W. Eline Jr., David Kraft, Bernie Bowling, and Al Ring, whose website (see page 127) contains a world of information about St. Matthews. Others who helped us with photographs or in various other ways include Judy Steinhauer and Mary Sue Ryan of the Girl Scout Council of Kentuckiana, Ellen Kaelin Venhoff, Carol Tobe, Tom Zehnder, Tom Owen, Bob Moore, Ken Draut, Mike and Rich Ochsner, Julie Garrison of Baptist East Hospital, Shirley Harmon of Norton Hospitals, Shiela Wallace of the Jewish Community Center, Marsha Burton of the Inn at Woodlawn, and Marty Perry of the Kentucky Heritage Council.

In the photograph credit lines, we have used the following abbreviations where appropriate: Archdiocese of Louisville (AOL), Beargrass Christian Church (BGCC), Beargrass-St. Matthews Historical Society (BGSTMHS), Bethel-St. Paul Church (BSP), Harvey Browne Presbyterian Church (HBPC), Jefferson County Historic Preservation and Archives (JCHPA), Kentucky Heritage Council (KHC), Our Lady of Lourdes Catholic Church (OLOL), St. John's Lutheran Church (SJL), St. Matthews Baptist Church (STMBC), St. Matthews Chamber of Commerce (STMCC), St. Matthews Episcopal Church (STMEC), Trinity High School archives (THS), University of Louisville (U of L), and Waggener High School archives (WHS).

INTRODUCTION

The question "Where is St. Matthews?" is not an easy one to answer in any kind of precise way. When it was first incorporated in the 1950s, St. Matthews was a very compact town, located on several square blocks around what is called "the Point," the intersection of Frankfort Avenue, Shelbyville Road, Lexington Road, and Breckenridge Lane that had been the commercial center of the community since the early 19th century. Since the 1950s, St. Matthews has expanded in all directions, but there are smaller communities that have remained independent although surrounded by the larger town. In addition, the annexation struggle between St. Matthews and Louisville in the 1950s resulted in part of the commercial district, mainly along Lexington Road, becoming legally part of Louisville. For the purposes of this book, however, we are going to follow the commonly accepted understanding of where St. Matthews is. That is to say, St. Matthews is bounded on the north by Brownsboro Road, on the west by Cannons Lane to Frankfort Avenue, around the east side of the Masonic Home property, and north to Brownsboro on a line along Staebler Avenue, where it turns north at the Masonic Home property. We consider the southern boundary to be Dutchmans Lane from Cannons Lane to the intersection where it meets Breckenridge Lane, very near the Watterson Expressway, and the eastern boundary to be the Watterson, except for a small residential area east of the Watterson between Shelbyville Road and Westport Road. It is best to think of St. Matthews as former mayor Art Draut once described it: the town of St. Matthews is not the same as the community of St. Matthews.

John Floyd (1750–1783) was named a deputy surveyor in 1774 in what was then Fincastle County, Virginia. He was sent west to survey much of the land that became St. Matthews, and in late 1774, he moved his family to this land, which became known as Floyd's Station. In 1781, he was made commander of the Jefferson County militia, fought Native Americans in 1782, and died the following year in an Indian ambush while on a trip to Bullitt County. He is buried in St. Matthews, not far from Breckenridge Lane.

Floyd's Station was built in late 1774 in the middle of Floyd's property. It was a walled structure meant to offer some protection against Indian raids. The station remained on the property at least until Floyd's widow, Jane Floyd Breckinridge, died in 1812. After the Native American threat subsided near the end of the 19th century, more settlers came to Floyd's Station. Stagecoach routes were developed along roads to Lexington, Frankfort, and Shelbyville, which remain today as names of some of the most important streets in St. Matthews. The stagecoach continued to be the principal mode of transportation until the Louisville and Frankfort Railroad was completed in 1849. Virtually all of the land was used for agriculture, but a small business district grew up around a store and tavern owned by Daniel Gilman. For this reason, the area became known as Gilman's Point. In 1851, however, residents chose St. Matthews as the official name of the community since they thought it more appropriate to name the town after its one church, St. Matthews Episcopal Church, rather than its one tavern. Later, in the 1850s, a wave of settlers, mostly farmers, arrived in St. Matthews from the small Swiss town of Einsiedeln; they bore surnames such as Kaelin, Zehnder, Ochsner, Schoenbeckler, and Ehrler. Many of the descendants of these families still call St. Matthews home.

St. Matthews remained a farming community throughout the 19th century, developing a reputation for potato cultivation, along with recreational cockfighting. Many of these families prospered and built fine large homes, a few of which still survive. But as the city of Louisville, just to the west, continued to grow, the push for more housing began encroaching on the farmland of St. Matthews. The first residential subdivision was laid out in the area of Cannons Lane and Grandview Avenue in 1899. In 1901, the interurban streetcar line connected St. Matthews with downtown Louisville, allowing easier commuting, and in 1906, the Bank of St. Matthews opened. Still, farming, especially potatoes, continued to flourish, and St. Matthews billed itself the "potato capital of the world." Potato growing in St. Matthews was impressive; in 1913, for example, the area exported 13 million pounds of potatoes.

Potato farming began to decline in the 1920s, when the commercial district along Lexington Road, Frankfort Avenue, and Shelbyville Road expanded, and more and more land was subdivided into residential lots. The Ohio River flood of 1937 caused many Louisvillians to seek housing in the relatively higher ground of St. Matthews, and the postwar housing boom, really a national phenomenon, also had a strong impact on the community. By 1950, the population of St. Matthews was estimated to be 10,000, and some claimed that it was the largest unincorporated area in the United States.

The prospect of additional taxpayers caused Louisville's city government to initiate annexation proceedings in 1946, and in 1950, St. Matthews responded by incorporating itself as a sixth-class city under Kentucky law. A lengthy legal struggle between Louisville and St. Matthews continued until 1956, with St. Matthews achieving independence as a fourth-class city and Louisville annexing a significant part of the St. Matthews business district.

The postwar years also witnessed a spectacular business boom, principally along Shelbyville Road east of St. Matthews. The completion of the Watterson Expressway (I-264) to Shelbyville Road in the early 1960s made the area much more accessible to automobile traffic. As a consequence, Shelbyville Road Plaza, a large outdoor shopping center, opened in 1955, and the Mall St. Matthews (originally called the Mall), an indoor facility, opened in 1962 less than a mile east of the plaza. Both are within a mile of the expressway. In addition, several automobile agencies bought land along Shelbyville Road to establish sales and repair centers. Some of the commercial expansion along Shelbyville Road has come at the cost of businesses in downtown St. Matthews—some have closed, while others have relocated to the shopping centers along Shelbyville Road.

As of 2015, St. Matthews boasts a population of about 18,000. It has one public elementary and one public high school, two private elementary schools, two Catholic elementary schools, and a large Catholic high school. People from all over the metro area come to shop at its malls, shopping centers, and automobile agencies, dine at its fashionable restaurants and brewpubs, and enjoy themselves at its movie theaters, parks, and other entertainment venues. Despite existing in the shadow of Louisville, St. Matthews has carved out its own identity over the years and stands today as a proud and independent community.

A note about street spellings in St. Matthews: Cannons Lane, Hubbards Lane, and Browns Lane are found spelled with or without the final "s" and with or without an apostrophe. Even city directories are not consistent. We have chosen to use Cannons, Hubbards, and Browns when referring to these three important streets because that is the way current city directories spell them. Also, Breckenridge Lane was named for the prominent Breckinridge family in the late 19th century. The misspelled "Breckenridge" came into use around the turn of the 20th century, and eventually the Jefferson County Fiscal Court declared that to be the official name of the street. Finally, although Shelbyville Road is now generally considered to begin at its intersection with Breckenridge Lane, that street was considered a continuation of Frankfort Avenue for various distances before the 1950s.

One

PIONEER DAYS

ST. MATTHEWS POSTMARK. St. Matthews had its own post office between 1851 and 1931, after which it was absorbed into the Louisville Post Office. Prior to 1851, a post office in what became St. Matthews was known as Lynnford; it had opened in 1849. (Authors' collection.)

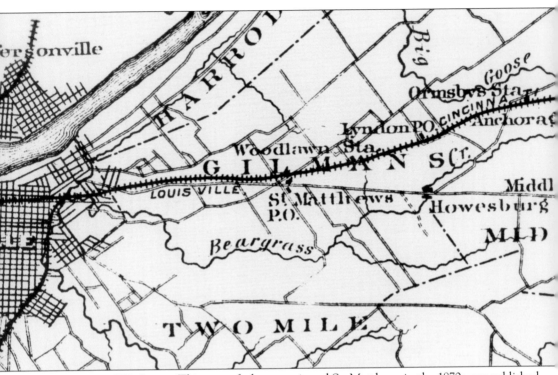

MAP FROM 1879 ATLAS. This map of what constituted St. Matthews in the 1870s was published in the *Atlas of Jefferson and Oldham Counties* in 1879. The center of St. Matthews, the area that became known as the Point, is directly above "St. Matthews P.O.," and the straight road leading east from the Point would become Shelbyville Road, now the main commercial thoroughfare in St. Matthews.

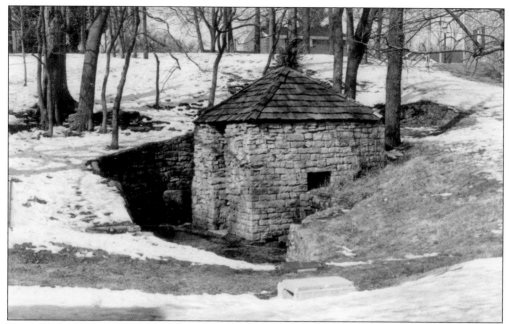

FLOYD'S STATION SPRINGHOUSE, C. 1779. This springhouse was built for Floyd's Station, the outpost constructed by John Floyd as a defense against Native Americans. It is a one-story stone building, with just one room, located on the south side of Prince William Street, not far from Breckenridge Lane. It was partly rebuilt in the 1960s and is the only material link to the original settlement in St. Matthews. (KHC.)

BROWN CEMETERY. James Brown (1780–1853) at one time owned more than 1,900 acres of land between Shelbyville and Taylorsville Roads west of the Oxmoor farm. The Brown family cemetery was located near present-day Brown Park. Brown came to the area about 1800 and initially worked as a clerk in David Ward's saltworks. Gradually, he bought up land until he owned a considerable estate. (KHC.)

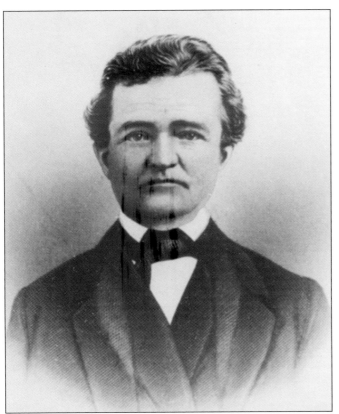

JOHN HERR. Herr (1806–1863) was the father of Albert G. Herr, served in the Kentucky legislature, and built a home in what is now Windy Hills in 1830, one of the outstanding houses in early St. Matthews history. By the time of his death, he owned about 1,000 acres of land that extended east to where Herr Lane is today. He is said to have been the best marksman and corn shucker in the community. The house was enlarged by Albert in 1876 with Italianate architectural features. (BGSTMHS.)

ALBERT G. HERR. The son of John Herr, Albert (1840–1899) owned the Magnolia stock farm, which he inherited from his father. He took an interest in transportation improvements from an early age and brought about the building of a turnpike east from St. Matthews using some of his own money to complete the job. Herr is remembered for the tragedy at his daughter's wedding reception at his home in 1891, when at least six people, including the groom, died from food poisoning. (BGSTMHS.)

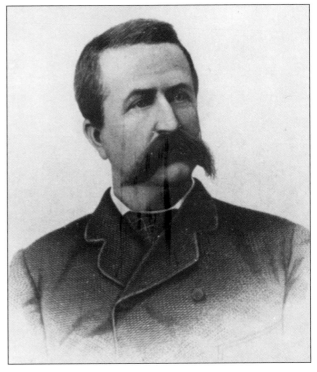

HENRY NANZ. Founder of the present-day Nanz & Kraft Florists, the oldest continuing business in St. Matthews, Nanz (1819–1891) emigrated from Germany, where he had been a horticulturalist, in 1850 and started the business at a downtown Louisville location. He brought his son-in-law H. Charles Neuner into the business in 1876. In 1880, Nanz and Neuner erected a large number of greenhouses on property in St. Matthews that Nanz had bought in 1866. There they grew flowers to supply their downtown store. (David Kraft.)

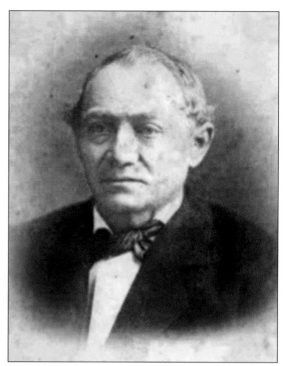

HENRY A. KRAFT JR. Kraft (1840–1915) joined Henry Nanz in the flower business in 1880 after Charles Neuner left it to pursue other interests. Kraft was born in Germany, came to the United States in 1859, fought in the Civil War, and worked as a butcher after the war before going into the flower business. It has remained in the Kraft family ever since. Nanz and Kraft moved their retail store to Breckenridge Lane in St. Matthews in 1918 and adopted the current name of Nanz & Kraft Florists in 1958. (David Kraft.)

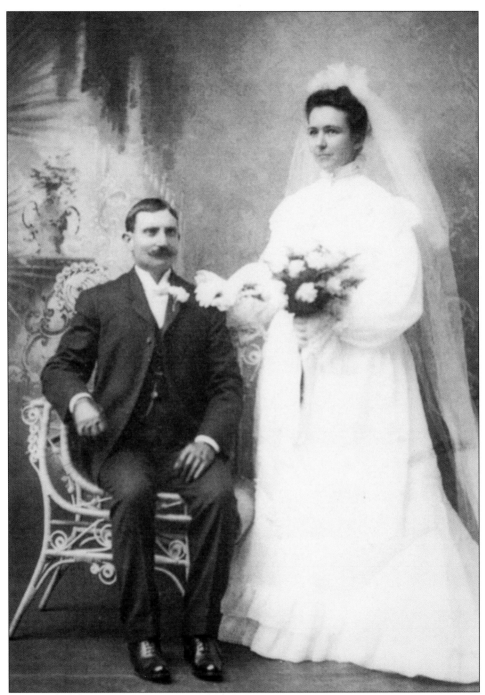

JOHN AND MAGGIE WINKLER ROSTETTER. Another prominent St. Matthews family of the late 19th century, John Rostetter and Maggie Winkler were married in 1872 and had two children. Maggie's father, Adam J. Winkler, was a German immigrant who lived near the Eight-Mile House on Shelbyville Pike, and her sister Anna "Nannie" Winkler married Charles Ochsner Sr., a member of the Ochsner family, which has been involved in the automobile service business for many years. (BGSTMHS.)

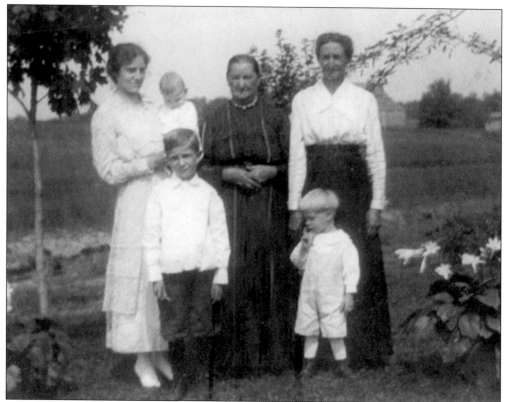

Four Generations of Zehnders. The Zehnder family was among the group of settlers that came from Einsiedeln, Switzerland, about 1854. They became dairy farmers and operated a store near the Point in the early 20th century. Shown here in the mid-1920s are, from left to right, Clara Bockting Zehnder, Dorothy Zehnder, Dominic Zehnder, Clara's grandmother, Hilliard Zehnder, and Clara's mother, Josephone Zehnder. (Tom Zehnder.)

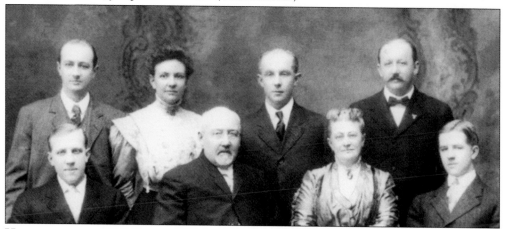

Henry and Sally Ward Kraft. Sally Ward (1851–1913) married Henry A. Kraft Jr. in Louisville about 1869. Henry eventually became a partner in the Nanz & Neuner florist business, replacing Charles Neuner. They had six children: Henry C. (1870), Robert A. (1872), Mary (1874), May (1875), Edward (1876), and Louis (1890), all of whom lived long enough to pose for this photograph, which appears to have been taken shortly after 1900. (David Kraft.)

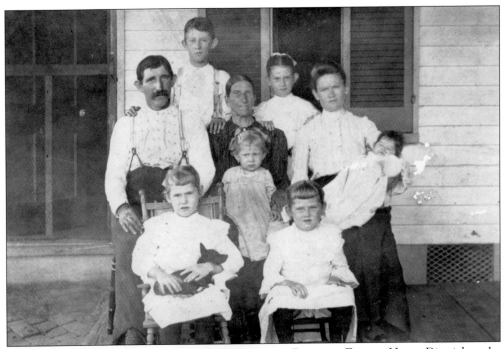

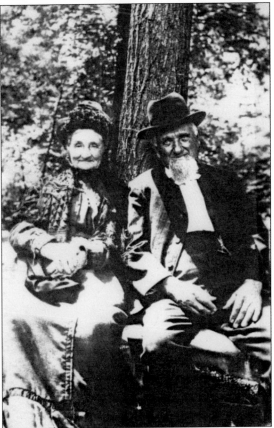

Dietrich Family. Henry Dietrich and his wife, Elizabeth Dickman Dietrich, were the maternal great-grandparents of current St. Matthews resident Ellen Kaelin Venhoff. In this photograph, they are shown with Henry's mother, Josephine Dietrich, in the center, and their six children: Albert and Eleanor are in the back, Elizabeth is holding Evelyn, and from left to right in the front are Mary, Clare, and Louise. Their second-youngest daughter, Louise, married Erwin Jacob "Epp" Stich, who was known locally as a baseball fanatic. (Ellen Kaelin Venhoff.)

Henry and Katherine Holzheimer Sr. The Holzheimers were another of the early arrivals to the St. Matthews area. Henry (1826–1919) and Katherine (1835–1926) were from Germany but married in Louisville in 1856. The family owned a 68-acre potato farm on the west side of Breckenridge Lane that was subdivided into residential lots in the 1920s. The *Louisville Times* noted that the sale of the Holzheimer property marked the "beginning of the end" of potato farming in St. Matthews. (BGSTMHS.)

Two

PRIVATE HOMES AND PUBLIC BUILDINGS

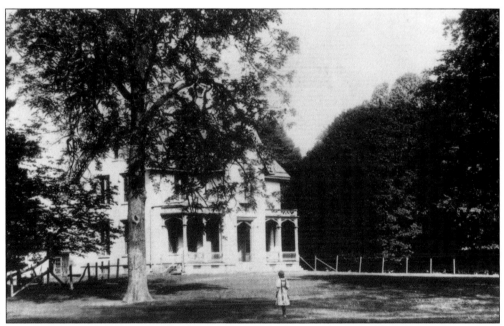

THEODORE BROWN HOUSE, 1854. This elegant farmhouse was built by Theodore sometime after he inherited the property from his father, James Brown, in 1854. The house was probably designed by the local architect Jacob Beaverson, who is known to have designed a similar Gothic-style house nearby. The house was set among 18 acres of mature trees. Brown, a minister, was married twice and fathered 20 children, 18 of whom were living at the time of his death. Since 1992, it has been a bed-and-breakfast called the Inn at Woodhaven, operated by Marsha Burton. It is located at 401 South Hubbards Lane. (Marsha Burton.)

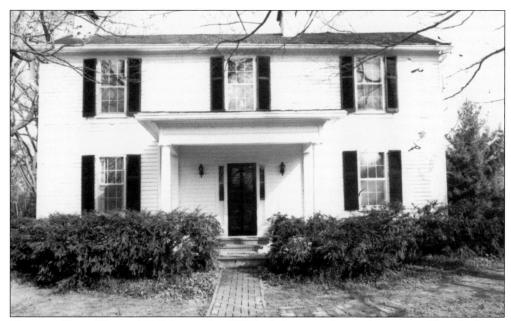

HUBBARD-RUDY HOUSE, 1906. Located at 4213 Rudy Lane, in the northeast part of St. Matthews, this is a typical two-story, three-bay, frame I house common in the area around the turn of the 20th century. It was built in 1906 for James H. Rudy, who had bought the land from his aunt Lydia Rudy Hubbard. The land was part of a land grant given to Daniel Rudy in the early 19th century. (KHC.)

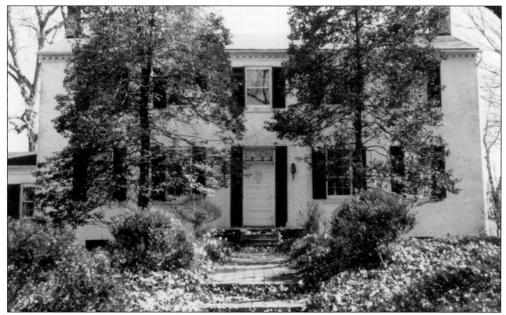

GEORGE HERR HOUSE, C. 1825. Located at 612 Rudy Lane, this house dates to about 1825. It is a two-story, Federal-style house with a brick cornice and a one-story wing extending out from the back of the main structure. A wing on the east end was added in the 1940s. The George Herr family cemetery is on the property. The house passed into the hands of George Herr's son Lewis Tyler Herr in 1875. (KHC.)

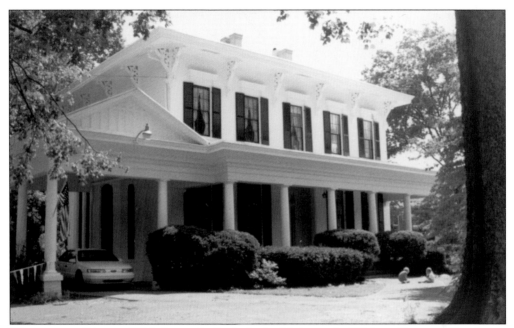

WINCHESTER HOUSE, 1854. James A. Burks built this house in 1854 on 42 acres of land near Woodville and Beargrass Creek. Burks employed the then-popular Italianate style of architecture in his two-story brick house with five bays. It features bracketed molding above the windows and complex brackets beneath the cornice. Burks called it Kentwood, and the W.C. Winchester family later acquired it. Its current address is 613 Breckenridge Lane. (KHC.)

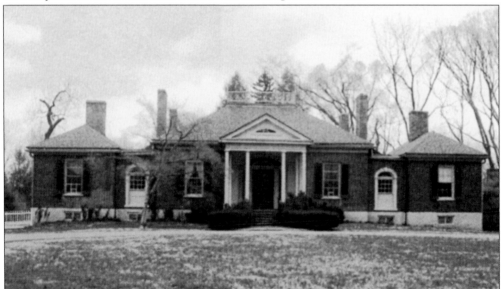

RIDGEWAY. Located at 4095 Massie Avenue, this house was built in the Federal domestic style about 1815 for Henry and Helen Bullitt Massie. The family originally owned 400 acres that they had purchased from Benjamin Sebastian in 1811. In 1834, Helen married J.L. Martin, reputedly the richest man in the state, and in 1857, she married Marshall Key, the brother of Francis Scott Key. In the 1930s, noted landscape designer Arthur Cowell developed gardens around the grounds. (KHC.)

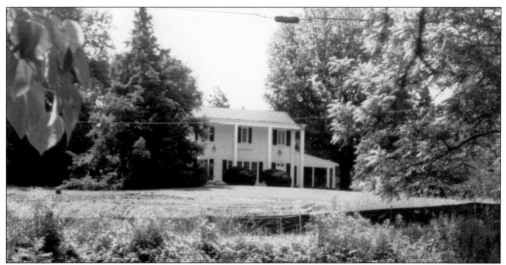

ALBERT'S ORCHID HOUSE. Built in the mid-19th century, this home became well known at the turn of the 20th century as the Orchid House, as the Albert family raised orchids in several greenhouses on their property and wholesaled their flowers to local retail outlets. After they retired, the property was subdivided and became the neighborhood known as Orchid Place, part of the town of Woodlawn Park. (BGSTMHS.)

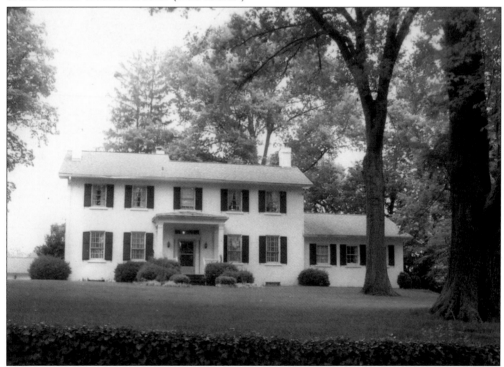

HERR-RUDY HOUSE. Located at 1001 Westgate Place (formerly 4319 Westport Road), this home was built by Thomas W. Hubbard about 1820. It is a five-bay, two-story, Federal-style brick house situated on land that John Herr bought from Joseph Edwards and then gave to his daughter Elizabeth on the occasion of her marriage to Vulcan Rudy in 1820. The front porch is a later addition. (Authors' collection.)

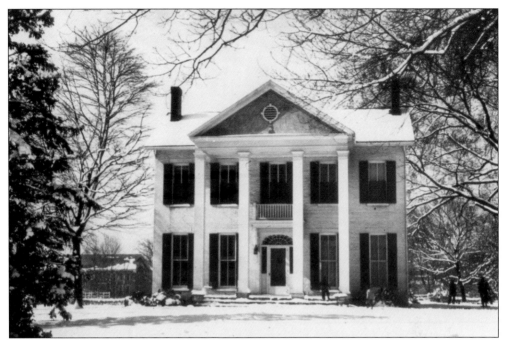

RICHARD HERR HOUSE. Herr built this home sometime after 1857 (probably between 1859 and 1865) as a wedding present for his second wife, Jane Ormsby. This is one of 10 Herr-Rudy houses built for members of these families during this era. Sometimes referred to as Elmwood, it is a two-story, five-bay, Federal-style structure with a columned portico that is a 20th-century addition. The house has other later additions and is located at 26 Leland Court, off Chenoweth Lane. (BGSTMHS.)

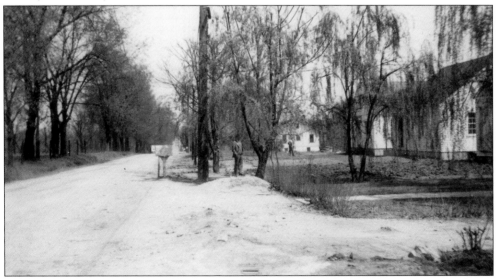

MASSIE AVENUE, LOOKING EAST. Massie Avenue is a residential street that runs east and west through the northern part of St. Matthews. In this 1942 photograph, one can see that Massie Avenue was still unpaved, and houses had been fairly recently constructed on the south side, while a farm still occupied the north side. Further residential development would come quickly after World War II. (JCHPA.)

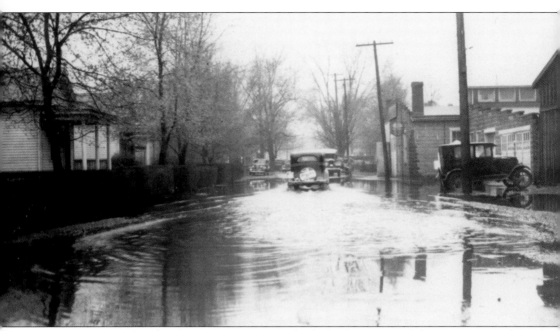

St. Matthews Avenue, Looking South. The lack of a sewer and drainage system plagued certain streets in St. Matthews before the 1960s. This 1940 photograph offers a south view toward Westport Road off St. Matthews Avenue, capturing the mixed development occurring there. On the east side, there is commercial development, probably related to the produce exchange, while on the west, houses line the street. (JCHPA.)

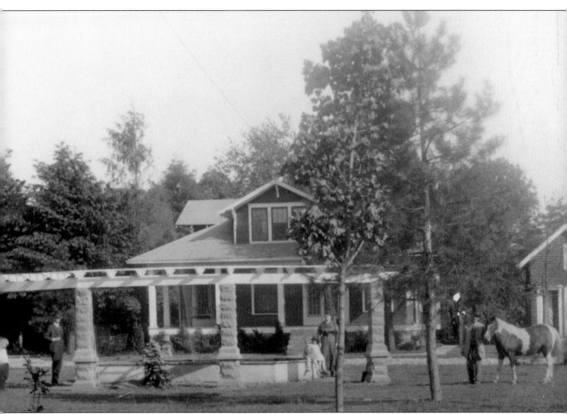

TONY ELINE FAMILY HOME, C. 1925. A.J. "Tony" Eline added real estate sales to automobile sales and service in 1912 and developed a neighborhood called Maplewood, located in the area bounded by Grandview Avenue, Breckenridge Lane, Nanz Avenue, and Fairfax Avenue. Around 1920, he moved his family into this house at 4020 Shelbyville Road, at the corner of Fairfax Avenue, very close to Maplewood. The house had a fishpond and an elaborate trellis in front and a garage on the side. By 1950, commercial growth along Shelbyville Road had made the house less attractive. The front yard became the home of the Fairfax Building, and by 1970, the Eline house had been razed. (Sidney W. Eline Jr.)

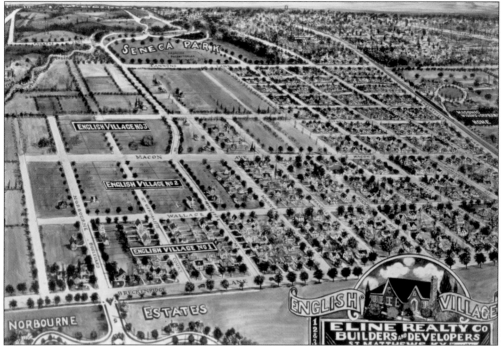

PLAN OF ENGLISH VILLAGE, C. 1935. By the 1930s, the Eline Realty Company was probably the leading real estate developer in St. Matthews. English Village was a large subdivision located between Breckenridge Lane and Cannons Lane between Hycliffe Avenue and Norbourne Boulevard, platted out in the mid-1930s. (Sidney W. Eline Jr.)

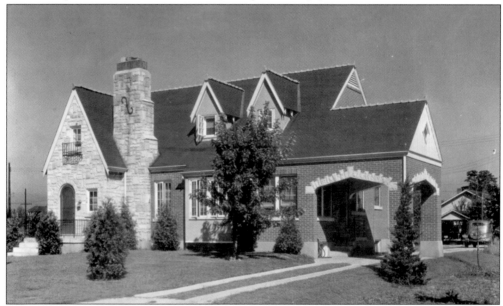

TYPICAL ENGLISH VILLAGE HOME, 1939. The rather large homes in English Village were designed in an English cottage style that was popular in residential construction. This house, located at 3813 Hycliffe Avenue, looks much the same in 2015 as it did when it was built about 1938. (Sidney W. Eline Jr.)

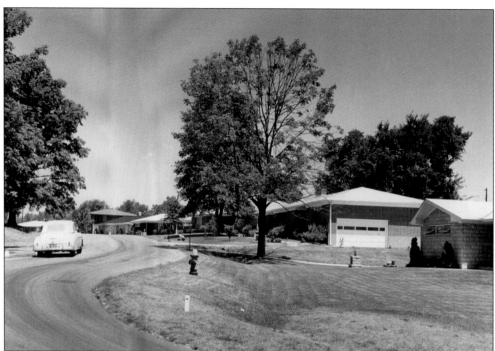

SAMOA WAY, 1959. The Eline Realty Company developed this street, which lies just to the west of Cannons Lane off Old Cannons Lane, in the mid-1950s. It is lined with large, one-story, hipped-roof houses with wide eaves, and except for the maturation of the trees, it has changed little over the years. (Sidney W. Eline Jr.)

KENBAR REALTY COMPANY ADVERTISEMENT, C. 1939. The Eline Realty Company was not the only one developing residential neighborhoods in St. Matthews during the 1930s. C. Robert Peter Sr. and his son C. Robert Peter Jr. advertised homes along Hycliffe Avenue just west of Breckenridge Lane in the late 1930s. The Peters' advertisement touted theirs as the "prettiest" subdivision in the East End and reminded customers that they could "buy on easy terms." (Al Ring.)

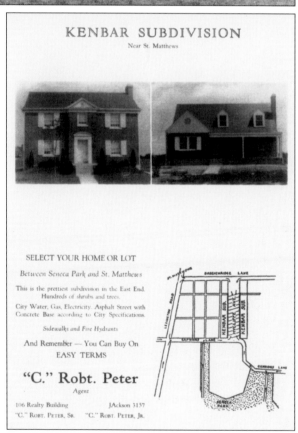

KENBAR SUBDIVISION
Near St. Matthews

SELECT YOUR HOME OR LOT

Between Seneca Park and St. Matthews

This is the prettiest subdivision in the East End. Hundreds of shrubs and trees.

City Water, Gas, Electricity. Asphalt Street with Concrete Base according to City Specifications.

Sidewalks and Fire Hydrants

And Remember — You Can Buy On
EASY TERMS

"C." Robt. Peter
Agent

106 Realty Building JAckson 3157
"C." ROBT. PETER, SR. "C." ROBT. PETER, JR.

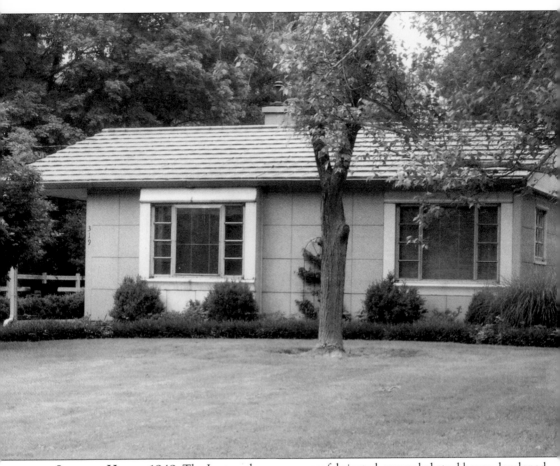

Lustron House, 1949. The Lustron home was a prefabricated, enameled-steel house developed by Carl Strandlund, a Chicago inventor, who was looking for a solution to the post–World War II housing shortage. Strandlund also felt that the durability and ease of maintenance of his houses would be welcomed by American families. About 15 of these were built in the Louisville area. This house, at 319 Westport Drive, has not been extensively modified, as many have, and appears in 2015 much as it did when it was built in 1949. (Authors' collection.)

ST. MATTHEWS FARMLAND. The agricultural land of St. Matthews was used principally for tobacco and hemp cultivation during the 19th century, but in the first decade of the 20th century, potato growing took over, at least in part to satisfy the growing demand from Irish immigrants. (JCHPA.)

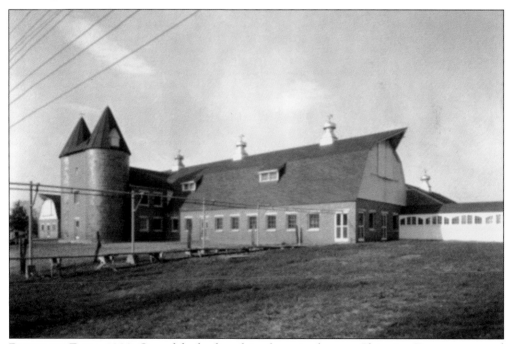

PLAINVIEW FARM, 1929. One of the leading dairy farms in the area, Plainview Farms was owned by R.C. Tway and located just east of St. Matthews north of Shelbyville Road. A fire in January 1941 destroyed 175 tons of hay, 50 tons of straw, and other food for dairy stock. The farm has been subdivided into a neighborhood called Plainview. (U of L.)

TREES ON WENDOVER AVENUE. By the 1960s, when this photograph was taken, the residential development of St. Matthews was largely finished, and streets, especially those between Breckenridge Lane and Cannons Lane, had matured into pleasant tree-lined thoroughfares with well-maintained homes. Wendover Avenue runs between Lexington Road and Dayton Avenue, one block east of Macon Avenue. (Tom Zehnder.)

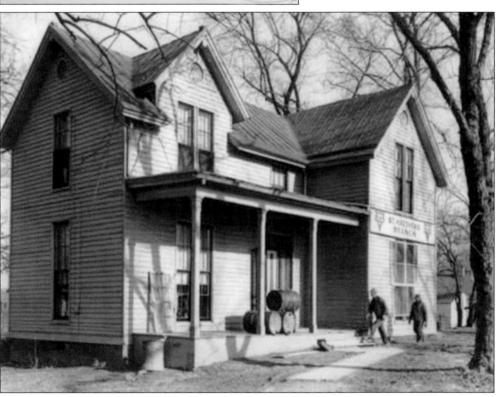

ST. MATTHEWS CITY HALL, 1951. This building, on St. Matthews Avenue, was once the rectory for the St. Matthews Episcopal Church. In the 1950s, it may have served for a short time as St. Matthews City Hall, but the evidence for this is inconclusive. When this photograph was made in 1951, the St. Matthews branch of the YMCA was leasing the building. Later, the building was burned as a training exercise for the fire department. (BGSTMHS.)

ST. MATTHEWS CITY HALL, 1960–1994. St. Matthews built a new city hall at 201 Thierman Lane in 1960, with 5,500 square feet of usable space. The town outgrew the building by the early 1990s, bought the Greathouse Elementary School on Grandview Avenue for $1.3 million, and spent another $1 million renovating it into a city hall, police headquarters, and public library. In 1994, city officials, police personnel, and the library staff all moved into their newly refurbished spaces. The old city hall is now a law office. (Authors' collection.)

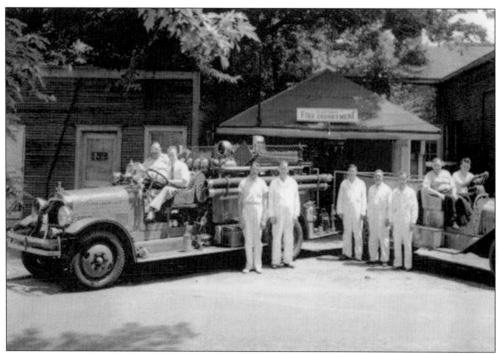

ST. MATTHEWS FIRE DEPARTMENT, 1940. The St. Matthews Fire Department was formed as a voluntary association in 1919 and moved into this station at 109 Breckenridge Lane in 1924. Posing in front of that building in 1940 with two of their trucks are, from left to right, John Feierbend, Capt. John M. Monohan Jr., Chief Raymond Young, Assistant Chief Henry Monohan, William Leitsch, Richard Herdt Sr., Lt. Marty Kamer, George Wilrater, and Bernard Handel. (SMCC.)

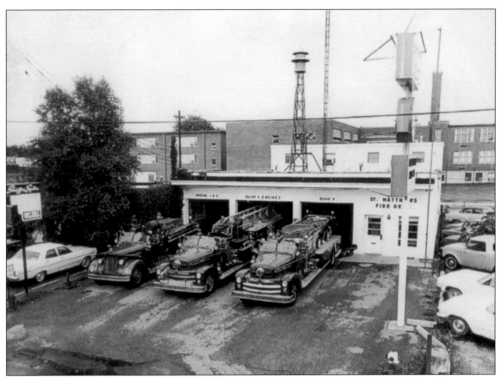

ST. MATTHEWS FIRE DEPARTMENT, 1964. A new fire station at 117 St. Matthews Avenue was opened in October 1952, with space for five fire trucks, offices, lockers, and a kitchen. At that time, the minimum rate for fire protection in St. Matthews was $3 per year. In 1961, a 20-foot-by-50-foot addition was constructed onto the rear of the building, which can be seen in this 1964 photograph. (Al Ring.)

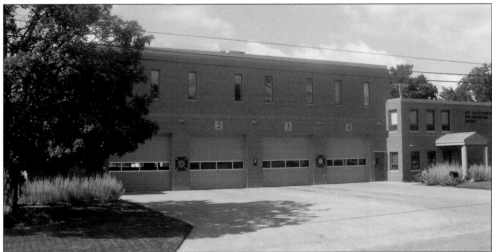

ST. MATTHEWS FIRE DEPARTMENT SINCE 1970. The need for a new fire station to replace the one at 117 St. Matthews Avenue was apparent by the 1960s. A contract for $226,920 was let to W.T. Briscoe Builders in April 1969 to construct a modern station at Lyndon Way and Sears Avenue, not far from city hall. The building was dedicated in April 1970 and is still in use in 2015. (Authors' collection.)

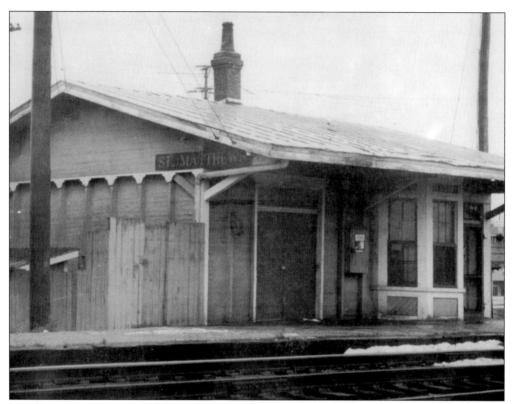

LOUISVILLE AND NASHVILLE RAILROAD DEPOT. The Louisville and Nashville Railroad was chartered in 1850 and began passenger service to Cincinnati about 1881. Railroad maps indicate a stop in St. Matthews (then called Gilman's) as early as 1886. The St. Matthews depot was located at 3905 Westport Road, just east of the intersection with Chenoweth Lane. Passenger service was discontinued in 1955, but an agent handled freight trains at the depot until June 1965. It was torn down in December 1965. (BGSTMHS.)

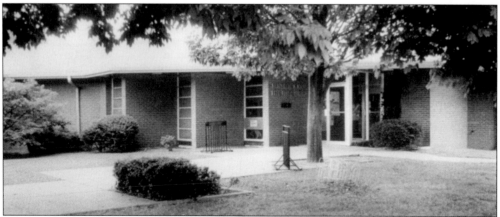

SIDNEY ELINE MEMORIAL LIBRARY. Named for A.J. Eline's son Sidney Eline, who was killed in World War II, and built on land provided by Eline, this library served to replace the painfully small public library branch at 133 St. Matthews Avenue. Located at 4201 Church Way, the library was dedicated in 1959. In 1994, it moved to the newly renovated Greathouse School building on Grandview Avenue, and the old building became a day-care center. (Sidney W. Eline Jr.)

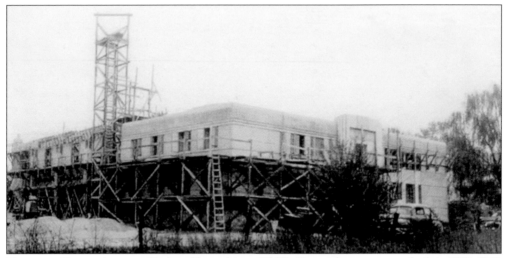

NATIONAL GUARD ARMORY. Designed by architect Edd R. Gregg, the armory was built in 1941–1942 as a Works Progress Administration (WPA) project. It was the headquarters for the Kentucky National Guard 149th Infantry Regiment, but that unit had been deployed overseas by the time the armory was finished. The regiment used it after the war until the lack of space, especially for a motor pool, rendered it obsolete in the early 1960s. (Al Ring.)

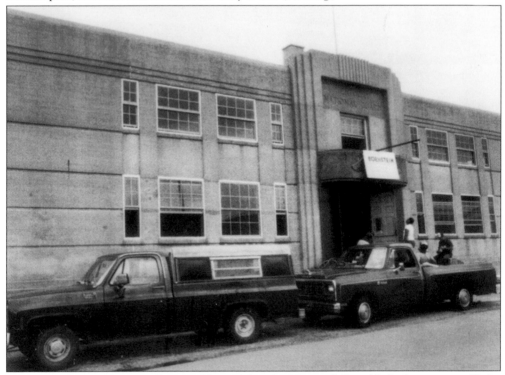

NATIONAL GUARD ARMORY FUTURE USES. After the National Guard left, the city installed a roller-skating rink in the armory, which was a popular attraction for several years in the 1960s and 1970s. Trinity High School bought the armory in 1985, spent $350,000 renovating it, and now uses it as the school's arts and communications building. The school's archives are also housed in this building. (THS.)

Three

CHURCHES

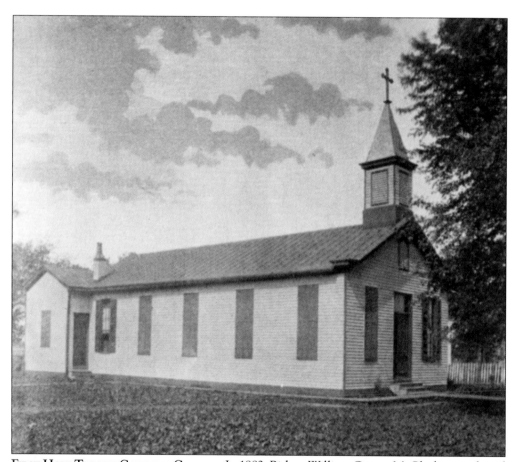

FIRST HOLY TRINITY CATHOLIC CHURCH. In 1882, Bishop William George McCloskey purchased land and a house in St. Matthews for $7,500. Holy Trinity Catholic Church and school, with Fr. Louis C. Ohle as pastor, thus began on what is now St. Matthews Avenue. This was one of the first suburban parishes in Louisville. (AOL.)

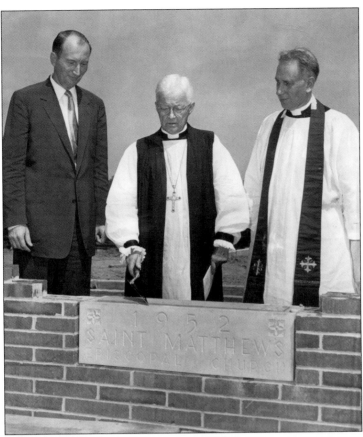

St. Matthew's Episcopal Church Dedication, June 21, 1952. From left to right, Henry Scheirich, Bishop Charles Clingman, and Rev. Bill Myll lay the cornerstone for the new St. Matthews Episcopal Church on Hubbards Lane in 1952. The first service was held in the new sanctuary (now Clingman Chapel and the Rehearsal Hall) on February 8, 1953. (STMEC.)

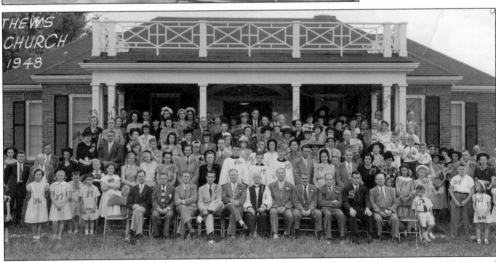

St. Matthew's Episcopal Church Reorganized, 1948. The original St. Matthews Episcopal Church began in 1839 and gave its name to the community in 1850. The church never recovered from a fire in 1858 but struggled on until 1913, as most members moved to St. Mark's in Crescent Hill. In 1948, with the population growing in the area, the Episcopal diocese began a new mission in the community. Sunday worship was held at the St. Matthews Women's Club until the sanctuary was built in 1952. (STMEC.)

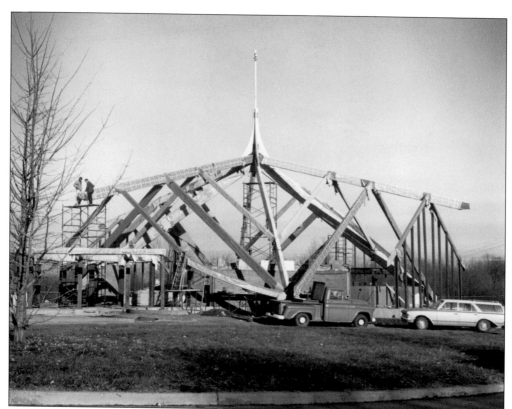

St. Matthew's Episcopal Church Under Construction, 1964. The distinctive design of the new church was considered quite avant-garde. It was meant to reflect a tent-like roof seen in early Christian gathering places. The design was open to God's world outside the church and provided a space for the community to worship in the round. (STMEC.)

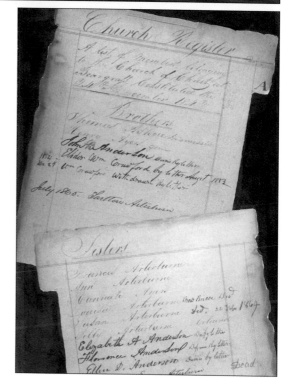

Early Registry of Beargrass Christian Church. The membership at Beargrass in the 1860s church registry contains many of the pioneers of St. Matthews. Family names such as Herr, Arterburn, Cannon, Gilman, Hubbard, and Rudy are still familiar in the area. (BGCC.)

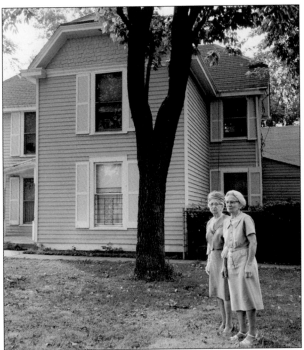

BEARGRASS CHRISTIAN CHURCH, FIRST PARSONAGE. Winnie Mae Dick (left) and Lois Akers, who had attended Beargrass since it was on Westport Road, stand in front of the first parsonage near the early church. Rev. Frederick W. O'Malley, a native of Canada, built the home himself in 1902. (BGCC.)

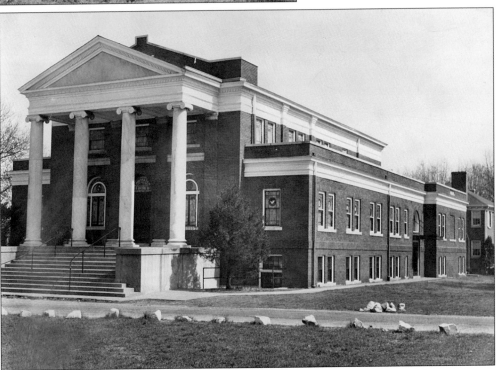

BEARGRASS CHRISTIAN CHURCH, 1939. Beargrass Christian's original church moved from Westport Road near St. Matthews Avenue to its present site in 1917. It took many years of planning, purchasing, and selling other sites, such as one on Fairfax Avenue at Shelbyville Road, before the Shelbyville Road and Browns Lane sanctuary could be built. (BGCC.)

"As much as in me is, I am ready to preach the gospel to you. For I am not ashamed of e gospel of Christ: for it is the power of God unto salvation to every one that believeth." om. 1:15, 16.

"I will sing of mercy and judgement: unto thee, O Lord, will I sing."---Psalm 101:1.

E. L. AVERITT
EVANGELIST
ST. MATTHEWS, KY.

E. L. AVERITT.

MRS. E. L. AVERITT,
Personal Worker and Soloist.

ADVERTISEMENT FOR EVANGELIST E. L. AVERITT. Ervin Averitt (1884–1974) and his wife, Blanche E. (Wyatt) Averitt (1884–1975), were Baptist evangelists who lived and preached in Louisville for a number of years after World War I. Ervin published a hymn, "I Am Saved," in 1912 and served as a chaplain with the 112th Infantry of the American Expeditionary Forces in the war, while Blanche did church work in Portsmouth, Ohio. (BGSTMHS.)

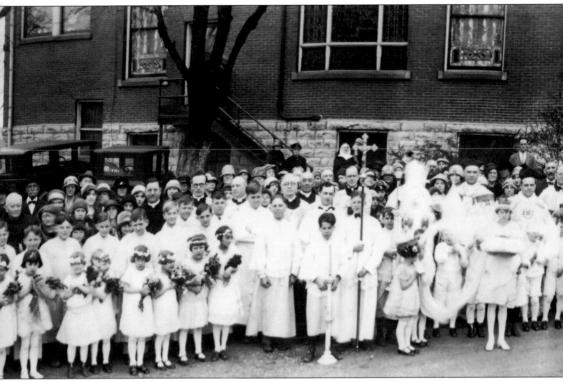

Holy Trinity Celebrates Father Besinger's Silver Jubilee, 1927. From its founding in 1882 until 1925, Holy Trinity Church in St. Matthews was served by priests who belonged to the diocese of Louisville. In 1925, Fr. Bartholomew F. Besinger, CPPS (Congregation of the Precious Blood), became pastor and served until 1938. The parish thrived under his leadership, and the

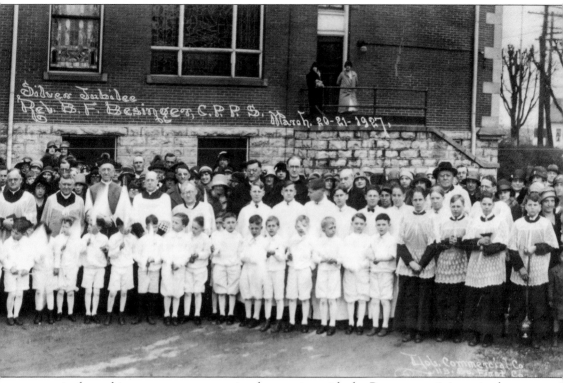

community knew him as open to ecumenism by meeting with the Protestant ministers in the community. His photograph hangs in the Zachary Taylor American Legion Post on Shelbyville Road. (Ellen Kaelin Venhoff.)

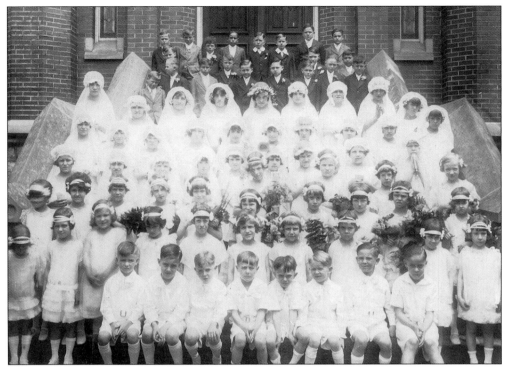

HOLY TRINITY CATHOLIC CHURCH FIRST COMMUNION CLASS. First Communion celebrations are a great parish event, as evidenced by this early-1920s class at Holy Trinity Church. After their First Communion, the girls became members of the Young Ladies' Sodality, wore a medal, and received Communion monthly as a group. (Holy Trinity Church.)

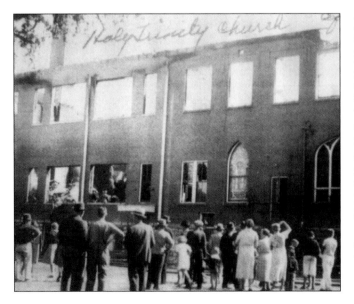

HOLY TRINITY CATHOLIC CHURCH FIRE, 1937. One of many church fires in the St. Matthews area devastated Holy Trinity church and school in 1937. Most of these fires were the work of arsonists. This one was found to be started by the son of the chief of volunteer firefighters. Sunday services were held in the gym, and Bethel United Church across Shelbyville Road offered its facility for classroom space while the building was being reconstructed. It was back in use by 1938. (Holy Trinity Church.)

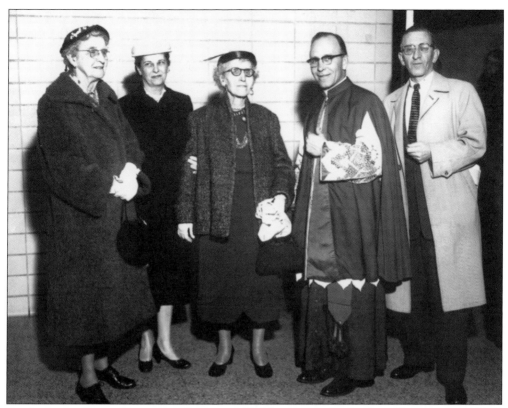

FR. ANTHONY GERST CELEBRATES ELEVATION TO MONSIGNOR. Fr. Anthony Gerst, pastor of Holy Trinity Church and founding pastor of Our Lady of Lourdes, celebrates his elevation to monsignor with his family in August 1949. Family members are, from left to right, Clara Gerst (aunt), Elizabeth Gerst (sister-in-law), Lula Gerst (aunt), Monsignor Gerst, and Walter Gerst (brother). Gerst seldom used the title, preferring to be addressed simply as Father Gerst. (OLOL.)

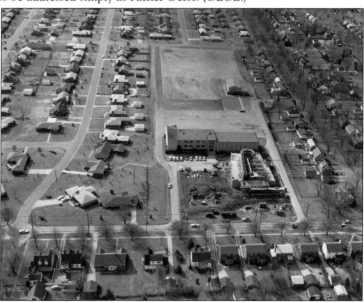

OUR LADY OF LOURDES CATHOLIC CHURCH. In the 1960s, Our Lady of Lourdes Church began construction of its present building. The original church structure, built in 1951, was attached to the school building, and when the new church was finished, it became a gym for the parish and school. (OLOL.)

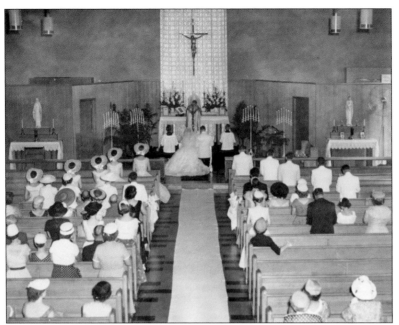

FIRST WEDDING AT OUR LADY OF LOURDES, JANUARY 13, 1951. Bill Steedly and Rita Roppell were the first in a long line of weddings at Our Lady of Lourdes. They remained members of the parish throughout their married life. Bill died several years ago, but Rita Steedly is still a member. (OLOL.)

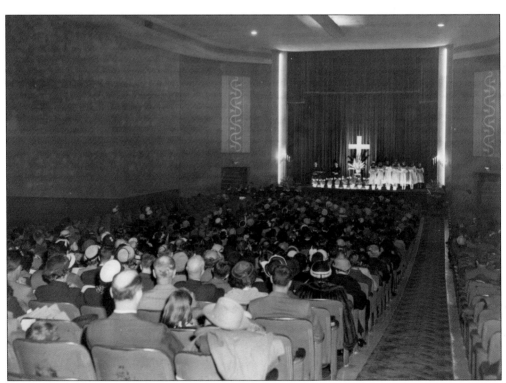

HARVEY BROWNE PRESBYTERIAN CHURCH EASTER SERVICE AT THE VOGUE THEATER. Since they had outgrown their original church and the new church was not complete, the Harvey Browne Presbyterian congregation used the Vogue Theater for Sunday services such as this Easter service in 1951. (HBPC.)

HARVEY BROWNE PRESBYTERIAN CHURCH, 1952. The Harvey Browne congregation assembled for the first Sunday service in their new church on January 20, 1952. In the 1920s and 1930s, several possible locations for a larger church were considered and even purchased. In the mid-1940s, church member Tony Eline and his sons Bud and Sidney contributed several thousand dollars for the purchase of land on Browns Lane. Zoning problems and parking needs delayed the building program until 1950. (HBPC.)

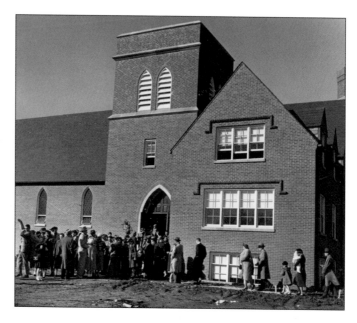

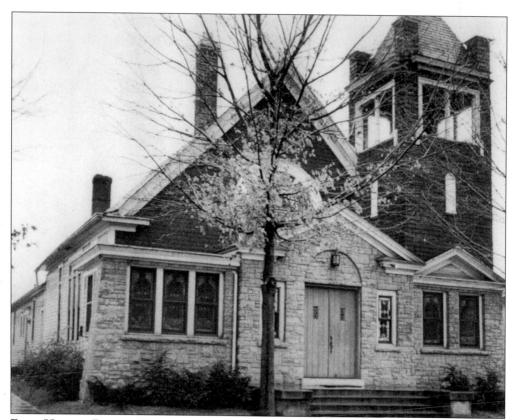

FIRST HARVEY BROWNE PRESBYTERIAN CHURCH. While it was a mission church, the Harvey Browne congregation met at Greathouse School, as so many St. Matthews churches did. The first church was on Bauer Avenue in a building that still stands and houses various offices. (HBPC.)

43

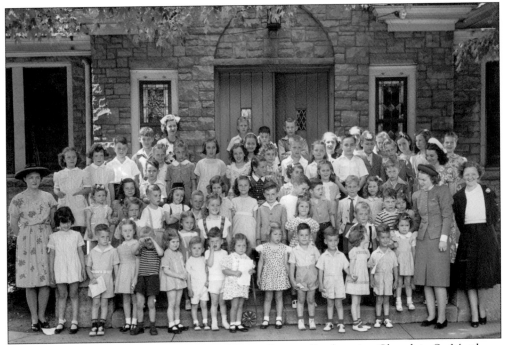

HARVEY BROWNE PRESBYTERIAN CHURCH. Harvey Browne Presbyterian Church in St. Matthews began in 1891 as a mission Sunday school by a group of young people from Crescent Hill Presbyterian. Young families have been the backbone of the congregation from the beginning. (HBPC.)

SECOND CHURCH OF CHRIST, SCIENTIST. In June 1916, Louisville's Second Church of Christ, Scientist was formed and first met at the Elks hall on West Walnut Street, now Muhammad Ali Boulevard. The land on Shelbyville Road was purchased in August 1952, and services were held from September 1954 until January 1957 at the Crescent Hill Woman's Club while the building on the St. Matthews land was constructed. (Authors' collection.)

BETHEL CHURCH FARMERS. It was a busy spring in 1924 when many members who were farmers pitched in to excavate the foundation of Bethel United Church of Christ's new building. This large group brought their horses and teams, picks, and shovels for several weeks of digging. The cornerstone was laid on August 17, 1924, and the church was dedicated on November 23 of that year. (Bethel-St. Paul Church.)

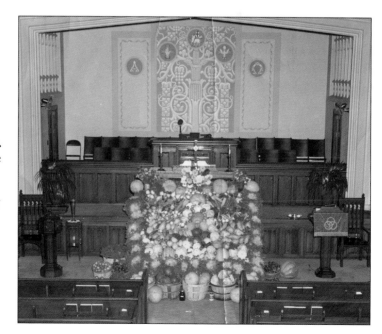

BETHEL CHURCH HARVEST CELEBRATION. In the 1920s, there were harvest celebrations at most churches since St. Matthews was primarily a farming community. The farmers who had dug the foundation at Bethel brought their harvests to church for a harvest celebration in 1925. (Bethel-St. Paul Church.)

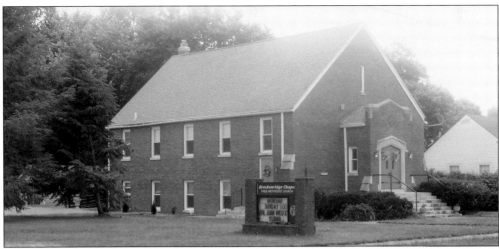

BRECKENRIDGE CHAPEL. St. Matthews Methodist built a church on Breckenridge Lane and Grandview Avenue in 1939 and worshipped there until 1947, when, needing more space, the congregation sold it to St. John Lutheran Church. The Lutherans, too, eventually needed more space, and when zoning regulations precluded expansion, they bought property at 901 Breckenridge Lane and built their present church in 1957. Since then, the chapel has been a Free Methodist church. (Authors' collection.)

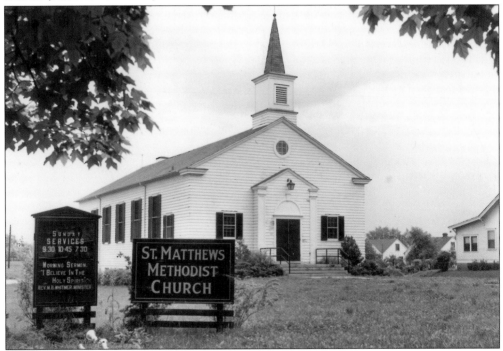

ST. MATTHEWS UNITED METHODIST CHURCH. The original Browns Lane St. Matthews United Methodist Church was moved from Bowman field in 1948. During World War II, and for some time thereafter, Bowman Field had quite a lot of military housing. There were some miscalculations, and the building was too wide for the stone entrance way at Hycliffe Boulevard and Breckenridge Lane. Trees were removed, and the entrance way was taken down and rebuilt. (St. Matthews Methodist Church.)

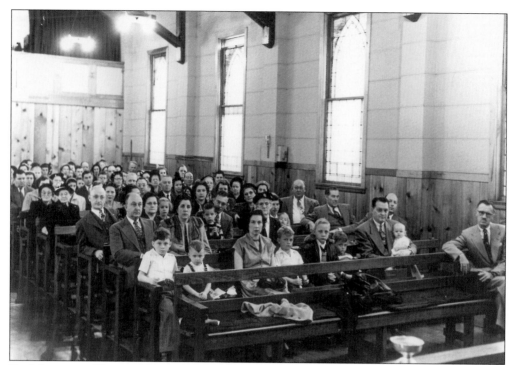

ST. MATTHEWS UNITED METHODIST CHURCH AT WORSHIP, 1945. From the earliest years, St. Matthews Methodist has had a growing congregation. The church growth eventually necessitated moving into its third and present sanctuary. (St. Matthews Methodist Church.)

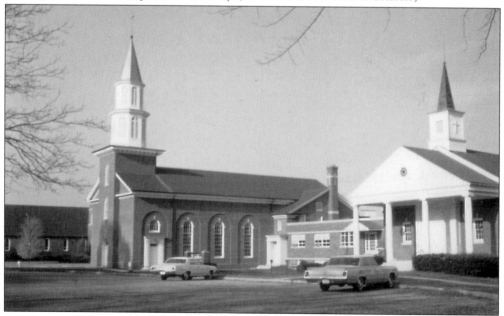

ST. MATTHEWS UNITED METHODIST CHURCH. St. Matthews Methodist's first church was at the corner of Breckenridge Lane and Grandview Avenue, in the building that is now the Breckenridge Chapel. They moved to their present location on Browns Lane, outgrew their original church there, and moved to a new larger sanctuary on Palm Sunday in 1963. (St. Matthews Methodist Church.)

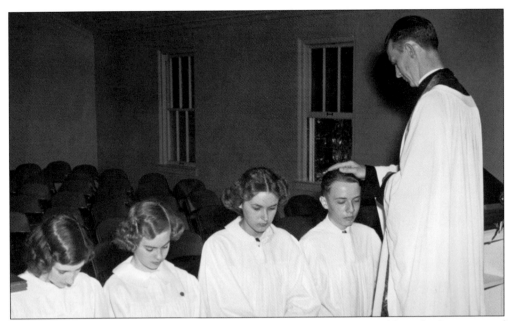

FIRST CONFIRMATION AT ST. JOHN LUTHERAN, 1949. Rev. Samuel P. Diehl Jr., the first pastor of St. John Lutheran Church on Breckenridge Lane, celebrates the church's first confirmation with, from left to right, Anne Quick, Sherrill Gordon, Beverly Seidel, and Norris Marchant. (SJL.)

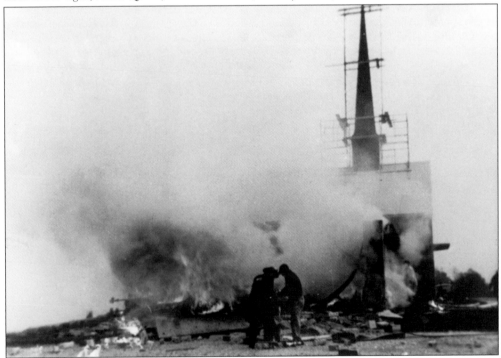

FIRE AT UNCOMPLETED ST. JOHN LUTHERAN, 1957. On October 21, 1957, a gas leak ignited, causing an explosion and fire at the nearly completed church. One wing was demolished, and the main structure was damaged extensively. The church was eventually rebuilt and dedicated on February 9, 1958. (BGSTMHS.)

Four

SCHOOLS

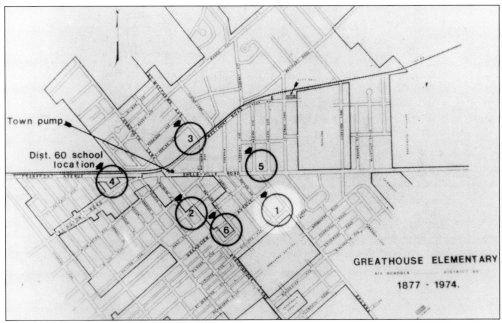

MAP SHOWING SIX LOCATIONS OF GREATHOUSE SCHOOL. The school that became known as Greathouse Elementary has had six locations in District 60, the district as designated in the county system. School No. 1 was a private one-room school. Schools No. 2 and No. 3 were also one-room schools. In 1888, School No. 4 began as one room but expanded to three rooms by 1915. School No. 5, now called Greathouse School, was enlarged several times before School No. 6 opened in 1939 in the present city hall and library building on Grandview Avenue. In 1980, the school merged with Gideon Shryock Elementary, and the Grandview Avenue building was closed. (BGSTMHS.)

TOMMIE GREATHOUSE. Greathouse (1842–1935) served as the sole teacher and principal to the District 60 school for 34 years in three different locations. Because of her years of service, the school became Greathouse School in 1915, three years before her retirement. (BGSTMHS.)

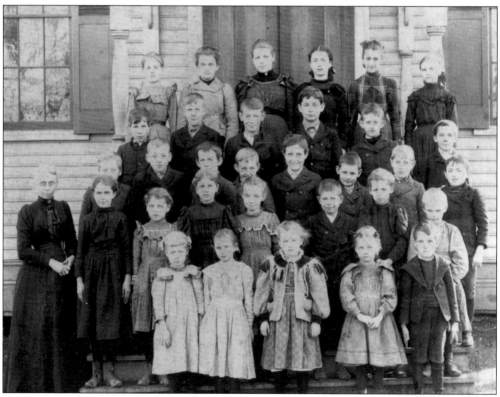

GREATHOUSE SCHOOL ON BAUER AVENUE. Built in 1910, Greathouse School No. 4 was a one-room school in the triangle formed by Frankfort Avenue and Lexington Road, led by teacher and principal Tommie Greathouse (far left). The school would soon expand and move to Shelbyville Road at Browns Lane by 1912. From 1876 to 1923, the St. Matthews Colored School was on Frankfort Avenue just to the east of Cannons Lane. (BGSTMHS.)

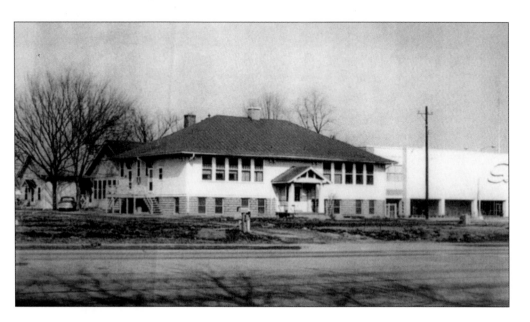

GREATHOUSE SCHOOL NO. 5 AND 1933 SIXTH-GRADE CLASS. In 1912, the school moved to this location on the north side of Shelbyville Road at Browns Lane. Up until this time, it was a private school, but with this move it became a public school and was officially to be known as Greathouse School. As evidenced by the photograph below, the school population was growing and would move to the larger building on Grandview Avenue in 1939. This location was sold to Eline Realty Company, which converted it into apartments. (BGSTMHS.)

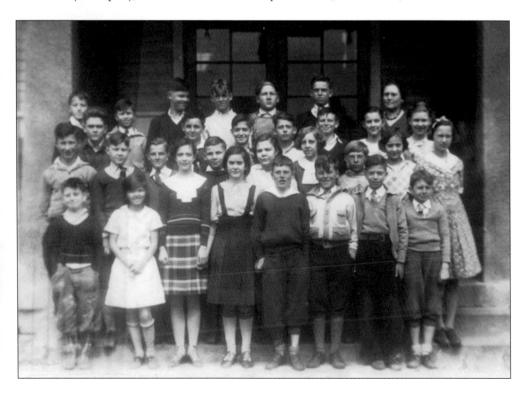

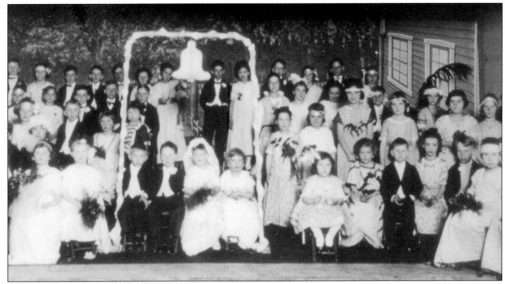

GREATHOUSE SCHOOL TOM THUMB WEDDING, 1922. Even before the Jefferson County schools instituted kindergartens, Greathouse School took an interest in the community's preschool children. In 1922, the school sponsored a Tom Thumb wedding for four- and five-year-olds in the St. Matthews area. (BGSTMHS.)

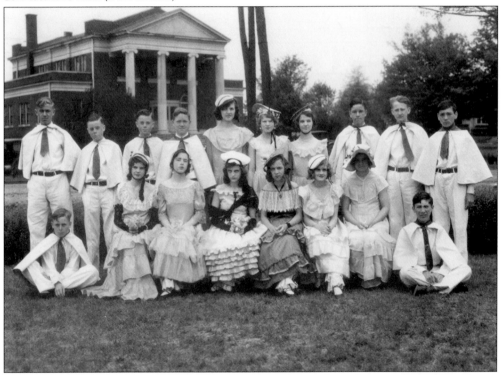

GREATHOUSE SCHOOL CLASS OF 1931. In 1931, the eighth-grade graduating class of Greathouse Elementary poses facing the school, which was on Shelbyville Road where the Chase Bank now stands. An undeveloped Shelbyville Road and Beargrass Christian Church stand behind the class. (Sara Eline Breeland.)

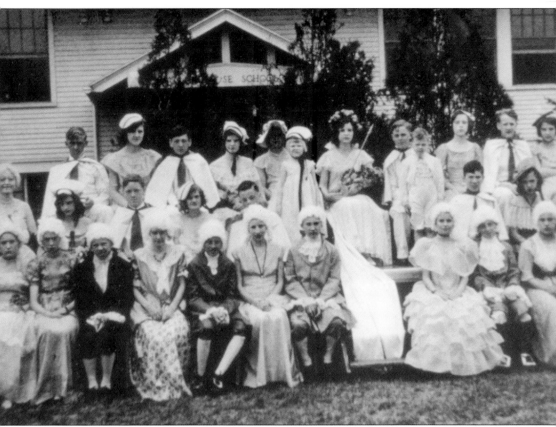

GREATHOUSE MAY DAY CELEBRATION. Principal Mayme Waggener (far left, second row) was proud of Greathouse School's 1931 eighth-grade costumed May Day celebration, pictured here in front of the school, then on Shelbyville Road. (BGSTMHS.)

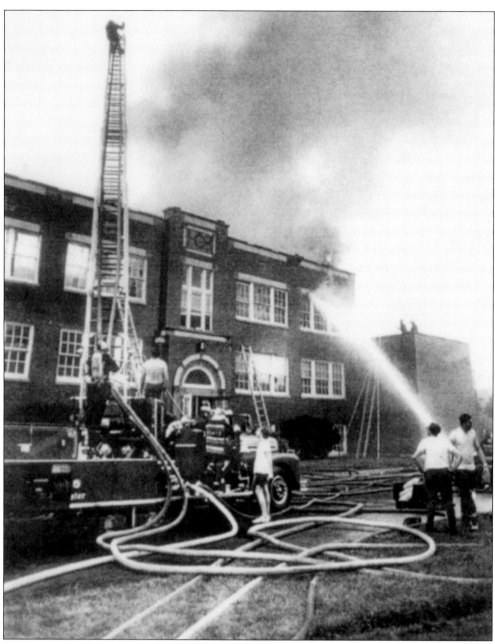

FIRE AT GREATHOUSE SCHOOL. In July 1971, a fire broke out at Greathouse School on Grandview Avenue. The St. Matthews Volunteer Fire Department's rapid response got the fire under control quickly, and after repairs, the school reopened in September. The school was merged with Shryock Elementary School in 1980, and the vacant building was later renovated and became the city hall, police department, and library in 1994. (BGSTMHS.)

HOLY TRINITY ELEMENTARY SCHOOL. Holy Trinity Catholic Church opened an elementary school in 1883, soon after the parish was formed. Early on, it was staffed by the Ursuline sisters of Louisville. Originally, it was in a home on St. Matthews Avenue near the church property, but a small schoolhouse was built in 1898. By 1913, the parish had grown to 165 families, and a new parish complex was built on Shelbyville Road and dedicated in 1915. The church and school remained there until 1953, when they moved to the present location on Cherrywood Road. The old building is now part of Trinity High School. (THS.)

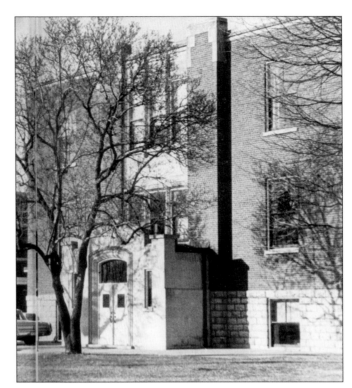

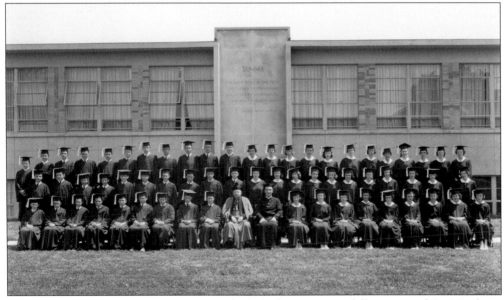

HOLY TRINITY SCHOOL CLASS OF 1956. The baby boom was in full swing, and St. Matthews schools were filling up. This class of 62 graduates is typical of the large classes in both the public and parochial schools that reflected both the growth of St. Matthews and the high birthrate of the era. (AOL.)

STIVERS ELEMENTARY SCHOOL. Orville J. Stivers School was named for a former school superintendent and opened in 1952 to relieve overcrowding at Greathouse Elementary. It remained open until 1980, when its students were redistributed to Chenoweth and Dunn Elementary Schools. The building, the first designed with prefabricated structural elements used later in several other county schools, closed and was sold in 1980 to became the home of the private Walden School. (Al Ring.)

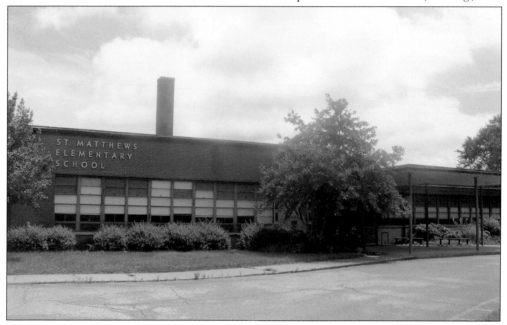

ST. MATTHEWS ELEMENTARY SCHOOL. While under construction, St. Matthews Elementary School was called Browns Lane School. It opened in 1955 as the baby boom was taking hold. Its property is adjacent to Mayme S. Waggener High School. At the time of its opening, there were three public elementary schools in St. Matthews: Greathouse, Stivers, and St. Matthews. It was intended as a school for kindergarten to sixth grade, but because of overcrowding at nearby Waggener, then a junior high school, some seventh- and eighth-grade classes were also held there. (Authors' collection.)

MAYME E. WAGGENER. As successor to Tommie Greathouse, Mayme Waggener (1876–1953) served the schools of St. Matthews for many years. She became principal at Greathouse Elementary School in 1918 and remained at that post until her retirement in 1946. Under her leadership, the school expanded from the four-room schoolhouse on Shelbyville Road to a new building on Grandview Avenue with 14 classrooms, an auditorium, a cafeteria, and a kitchen. She was honored by having Waggener High School named for her. (BGSTMHS.)

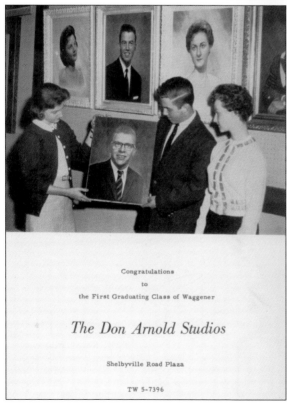

Congratulations
to
the First Graduating Class of Waggener

The Don Arnold Studios

Shelbyville Road Plaza

TW 5-7396

WAGGENER HIGH SENIORS WITH PORTRAIT OF PRINCIPAL JOHN LOWE. Waggener High School began as the first Jefferson County junior high in 1954 but soon added high school classes and graduated its first class in 1960. John Lowe, the first principal of the junior high, became the first principal of the high school. A school in the Hurstbourne neighborhood is named for him. (WHS.)

Finishing Touches on Waggener High School. The first building at Waggener in 1954 housed classrooms, an auditorium, and a gym for a junior high school. In 1956, it officially became a high school and home of the Waggener Wildcats. (WHS.)

Our Lady of Lourdes Church and School. Under Monsignor Gerst's direction, the school was built and opened in September 1950 with 224 children enrolled in kindergarten through seventh grade. (The eighth grade stayed at Holy Trinity in order to graduate with their original classmates.) The Ursuline Sisters of Louisville taught six of the eight grades; the two lay teachers taught kindergarten and fifth grade. Although the school opened in September, the Lourdes parishioners continued to attend Holy Trinity until the church was completed in December. (OLOL.)

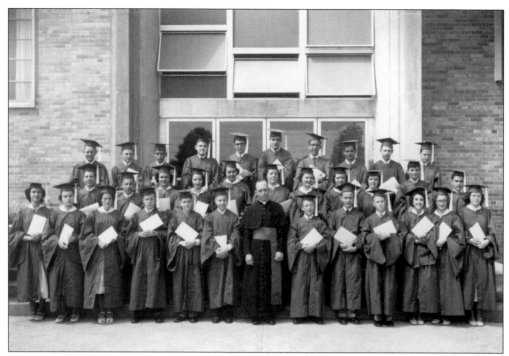

First Graduating Class of Our Lady of Lourdes. Our Lady of Lourdes's first graduating class is pictured here with Monsignor Gerst in 1952. When Our Lady of Lourdes parish was formed, the school was designed to be an essential part of the church's mission. It opened in 1950 with grades kindergarten through seventh grade. The eighth grade remained at Holy Trinity School so the students could graduate with their original classmates as the class of 1951. (OLOL.)

Our Lady of Lourdes Sixth Grade, 1956. The sixth-grade class of Our Lady of Lourdes in 1956 is shown here, with their teacher Sr. Janet Mary Peterworth, OSU. The Ursuline sisters of Louisville staffed the school at its beginning in 1950 and taught most of the grades. (OLOL.)

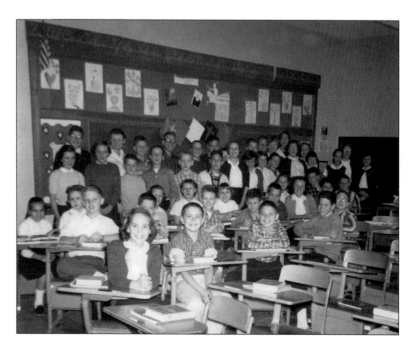

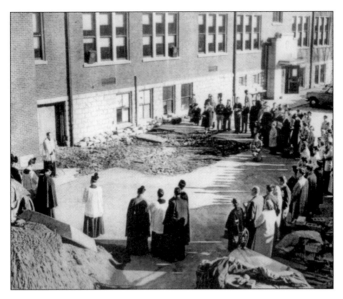

DEDICATION OF TRINITY HIGH SCHOOL, 1953. On September 8, 1953, Holy Trinity High School was dedicated by Archbishop John A. Floersh at the site of the former Holy Trinity Parish and School. Fr. Alfred W. Steinhauser was named the first principal. There was a wooden parish hall, a nuns' residence, a priests' rectory, a small playing field that abutted Westport Road, and a gymnasium that had been brought to Louisville by barge from Cincinnati, Ohio. Later, the word holy was dropped from the school name. (THS.)

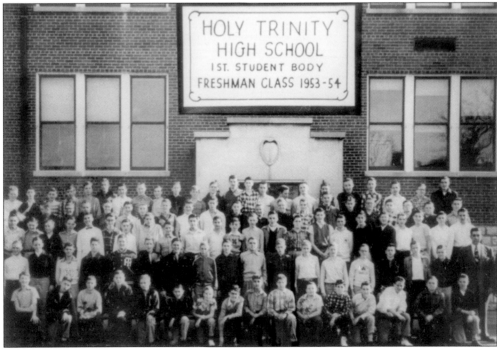

TRINITY HIGH SCHOOL FIRST GRADUATING CLASS, 1957. Trinity's first graduating class in 1957 had much to be proud of. In their four years, they saw the first *Shamrock* yearbook published, Floersh Hall completed, and a state champion cross-country team coached by Jerry Denny. (THS.)

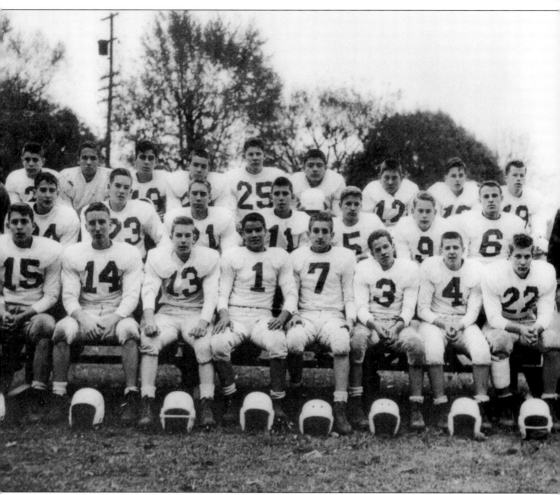

TRINITY HIGH SCHOOL FIRST FOOTBALL TEAM, 1955. The first Trinity football team in 1955 shows the spirit that continues to make Trinity's football program a nationally recognized powerhouse. The first game between Catholic school rivals Trinity and St. Xavier was a freshman game in 1954 that Trinity won 7-6. Head coach Mike McDonald is at the extreme right of the photograph, and Moose Krause, the quarterback, is seated in the center of the front row wearing no. 1. (THS.)

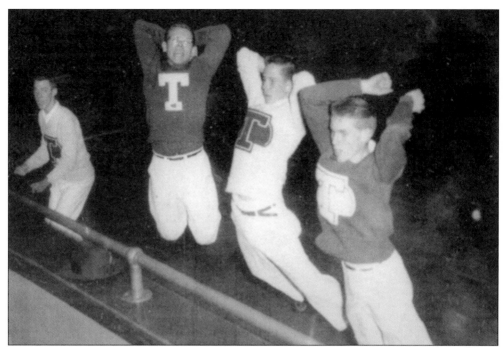

Trinity High School Cheerleaders, 1960. In the early years of Trinity High School, it would have been unheard of to have girl cheerleaders for an all-male school. These four fellows had no problem getting the crowd to respond. The Rocks were on their way to football glory. (THS.)

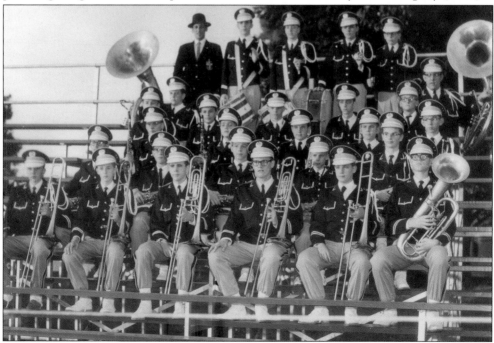

Trinity High School Pep Band. Along with the cheerleaders, the Trinity pep band added to the school spirit at football games. Director Gus Coin began the band in the late 1950s while heading the music department at Bellarmine College, now Bellarmine University. (Tom Zehnder.)

Five

COMMERCE BEFORE WORLD WAR II

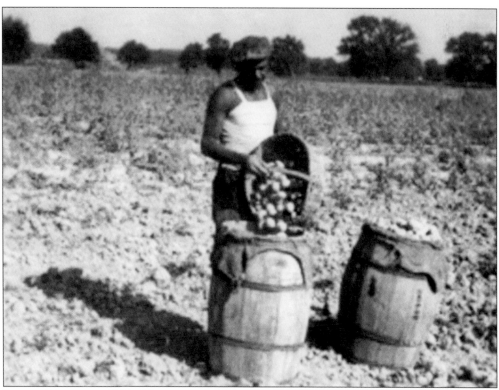

POTATO DIGGER, C. 1940. After potato farming began to expand rapidly in the early 20th century, there was a need for workers to harvest the crop. Potato diggers appear to have been itinerant farmworkers or local youth who were paid based on how much they gathered. In 1929, a digger earned 30¢ a barrel for potatoes. Back at the produce exchange, potatoes were graded as no. 1, no. 2, or no. 3. The worst potatoes, or those graded no. 3, were thrown aside and sold to farmers for hog feed, while the other two grades were sold to customers. (David Kraft.)

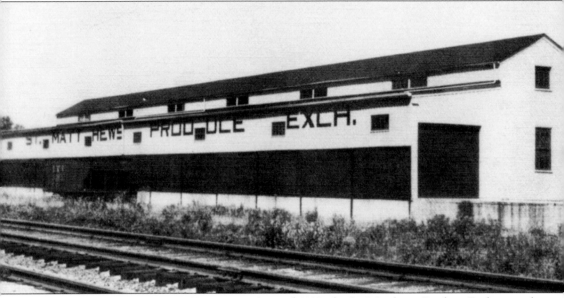

ST. MATTHEWS PRODUCE EXCHANGE. Around 1910, the St. Matthews Produce Exchange, along with the adjacent St. Matthews Ice and Cold Storage facility, was established at 131 Palmer Avenue, just off St. Matthews Avenue, for the purpose of serving the rapidly growing production of potatoes and other produce. An interurban spur was built to connect the exchange with the main rail line east from Louisville. The produce exchange moved in 1952 and closed in 1959 as a result of declining production. R.W. Marshall purchased the building in 1952 and moved his lumber yard and planing mill there from Breckenridge Lane. (BGSTMHS.)

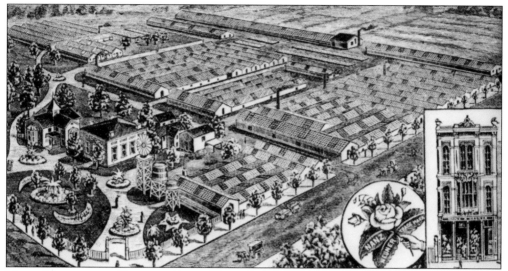

NANZ, NEUNER AND COMPANY GREEN-HOUSE ESTABLISHMENT. Henry Nanz bought 30 acres of land from Jacob Nicklies in 1872 to use for greenhouses in which to grow flowers and vegetables to sell in their downtown Louisville retail store. Eventually, 30 greenhouses were built near the intersection of Breckenridge Lane and Willis Avenue, near the current location of what is now Nanz & Kraft Florists. The greenhouses were gone by the 1940s, victims of commercial and residential development. (David Kraft.)

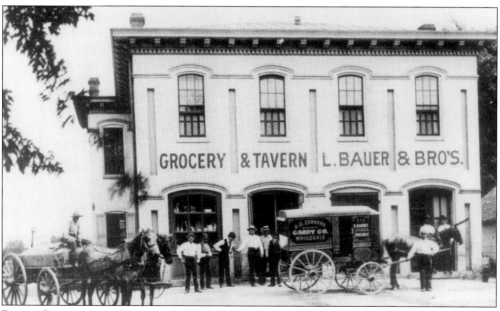

BAUER GROCERY AND TAVERN, 1895. Probably the most prominent business in St. Matthews before 1900, Bauer & Bros. Grocery and Tavern was a two-story brick building erected in 1871 at the northeast corner of Chenoweth Lane and Shelbyville Road. It was originally built and run by Henry Holzheimer, but the Bauer brothers—Louie, John, and Henry—acquired it in 1887, and the family ran it until Prohibition went into effect in late 1920. In 1921, the building was remodeled and became the Bank of St. Matthews. (BGSTMHS.)

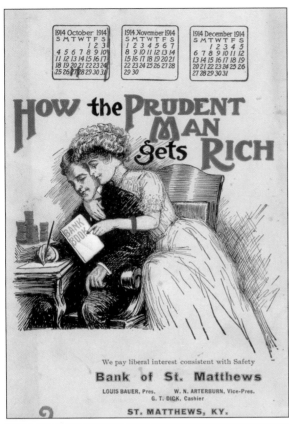

BANK OF ST. MATTHEWS BOOKLET COVER, 1915. Incorporated in 1905, Bank of St. Matthews signaled the increasing business orientation of the community. Most of the leading families of St. Matthews were original shareholders in the bank, including the Fenleys, Staeblers, Arterburns, and Bauers. Louis Bauer was president of the bank from its beginnings until his death in 1943. The booklet advises customers to be "prudent" with their money. (Authors' collection.)

FARMER'S BANK AND TRUST OPENING, 1924. Farmer's Bank and Trust opened on Frankfort Avenue in 1924 as the second bank in St. Matthews, and the opening appears to have been something of a civic celebration. The Great Depression forced the closure of the bank in late 1931, but it reopened in 1933 under the name of Farmer's and Depositor's Bank. Citizens Fidelity bought out the bank in the early 1950s. (Sidney W. Eline Jr.)

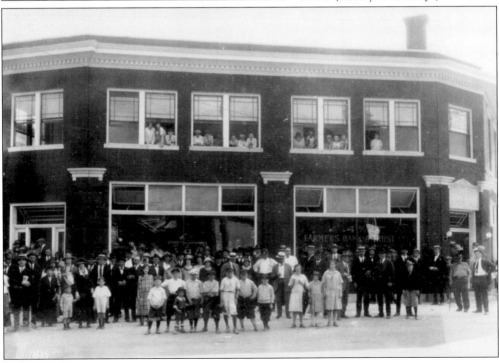

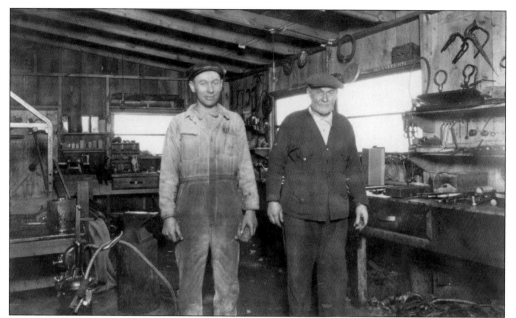

OCHSNER GARAGE, C. 1920. The Ochsner family was among those Swiss families that emigrated from Einsiedeln in the 1850s and put down roots in the Louisville area. Martin Ochsner built the Eight-Mile House on Shelbyville Road in 1882 and operated a restaurant and dance hall for 15 years. Martin's sons opened a garage across the road from the Eight-Mile House sometime before 1920 and operated it until 1937. Here, Frank Ochsner (right) and his son Herman stand in the garage. (Ochsner family.)

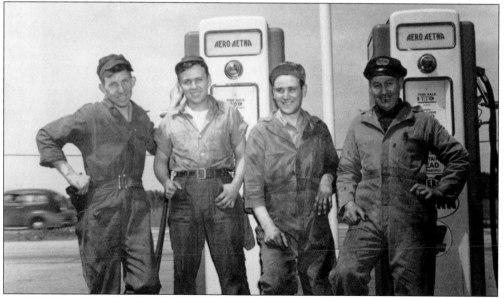

OCHSNERS AT THE GAS PUMP. In 1937, the two surviving Ochsner brothers split up, and Herman moved down to 4502 Shelbyville Road and opened a garage there, which remains in business as of 2015. In this c. 1950 photograph, Ochsner's mechanics, from left to right Jim Greenwell, Rich Ochsner, Bob Ochsner, and Herman Ochsner, pose in front of two of the gas pumps at the garage. (Ochsner family.)

ANTHONY J. ELINE. Anthony J. "Tony" Eline (1885–1967) was perhaps the most influential businessman in St. Matthews between 1913 and the 1960s. As a young man, he worked on his family's farm near what is now Seneca Park. In 1913, he began selling automobiles on St. Matthews Avenue, and by 1921 he had a large dealership at the corner of Breckenridge Lane and Frankfort Avenue (St. Matthews Station now occupies the building). About 1912, he began acquiring land in St. Matthews for residential development and prospered until the Depression. The real estate business picked up again by about 1936, and after the 1937 flood drove many Louisvillians to seek new homes in higher places, Eline did very well, developing several large subdivisions, including English Village, Elmwood, Brownsboro Estates, and Westport Heights. He was deeply involved in the community, serving as a bank director and donating money to a library that was named for a son who was killed in World War II. His grandson Sidney W. Eline Jr. now operates the Eline Realty Company. (Sidney W. Eline Jr.)

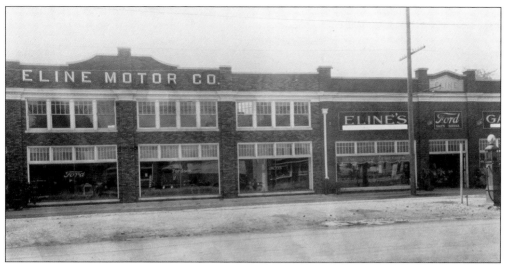

ELINE MOTOR COMPANY, 1920S. When it was constructed in 1915 on the south side of Shelbyville Road just east of Breckenridge Lane, the Eline building was the most imposing commercial building in downtown St. Matthews. A.J. Eline did so well selling Model T Fords that he soon doubled the size of the building to 35,000 square feet. He sold Fords until 1929, then Buicks and Pontiacs until 1935, when he formed Eline Chevrolet. Eline remained in the automobile business until 1954. The building still stands as a small shopping center called St. Matthews Station. (Sidney W. Eline Jr.)

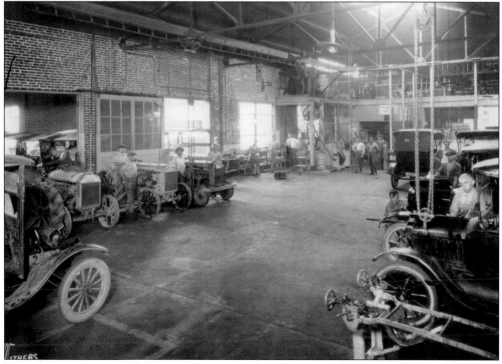

ELINE MOTOR COMPANY, INTERIOR. Eline not only sold automobiles but also serviced them, and much of the interior of his building was devoted to a spacious garage area. This 1920s photograph gives an idea of what a modern automobile service facility looked like. (Sidney W. Eline Jr.)

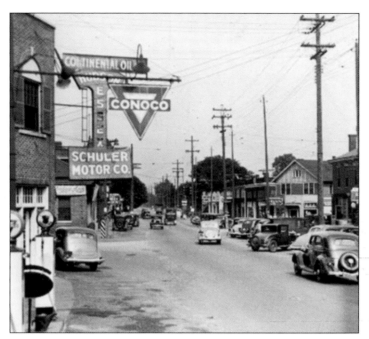

INTERSECTION OF LEXINGTON ROAD AND FRANKFORT AVENUE, 1930s. This was the center of downtown St. Matthews in the 1930s, and one can see businesses on both sides of the street, dominated by the Schuler automobile dealership, which sold Hudsons and Essexes, and a Conoco gas station next door. Other commercial establishments line the street for perhaps a block, and then the trees appear. (BGSTMHS.)

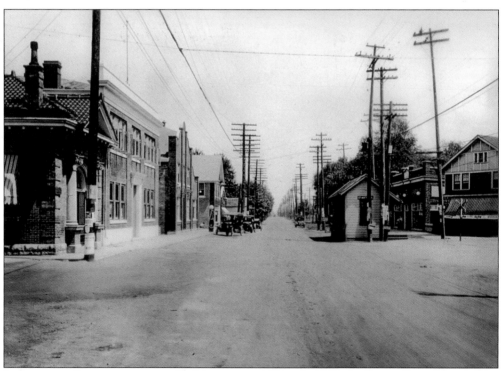

INTERURBAN RAILWAY THROUGH ST. MATTHEWS, 1920s. In 1907, the Louisville and Interurban Railroad began service to LaGrange, Kentucky, with a stop in St. Matthews, and in 1910 a route to Shelbyville also included a St. Matthews stop. Service on both these lines continued until the mid-1930s, when bus service took over. (BGSTMHS.)

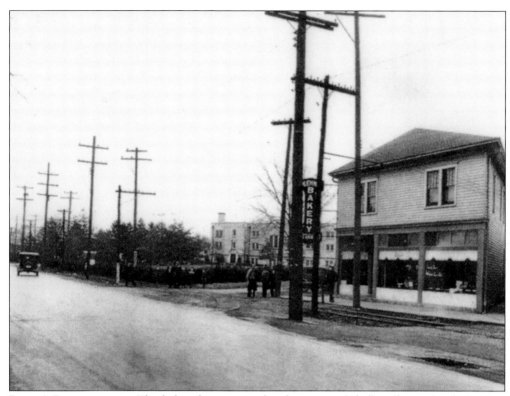

PLEHN'S BAKERY, 1920s. This bakery has remained at the corner of Shelbyville Road and Meridian Avenue since Kuno Plehn moved there in 1924. An immigrant from Kiel, Germany, Plehn (1883–1965) opened a bakery in downtown Louisville in 1922 and relocated to St. Matthews. In 1945, he retired and sold the business to his nephew Bernie Bowling Sr. (Bernie Bowling Jr.)

PLEHN'S BAKERY INTERIOR, 1920s. In the 1920s, Kuno Plehn (left) and longtime store employee Mamie Habich (right) were always ready to serve customers. In the center of is an unidentified employee. (Bernie Bowling Jr.)

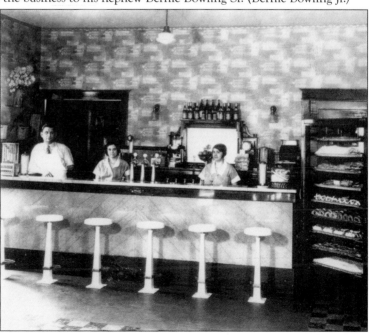

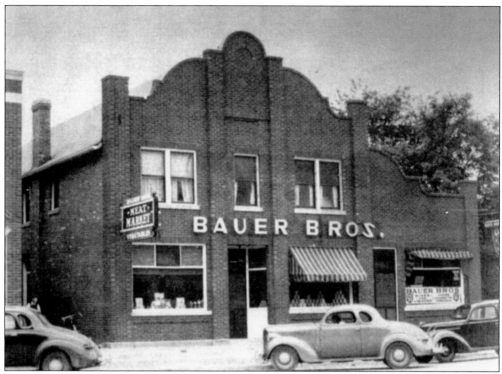

Bauer Bros. Grocery and Meat Market, 1930s. After the old Bauer Bros. Grocery and Tavern became the Bank of St. Matthews in 1921, the Bauers built a new store just east of their original building. It opened in the early 1920s and featured a distinctive facade in a Dutch-inspired style. While Prohibition prevented the legal sale of alcohol, the store sold "fancy" groceries and soft drinks and rented out a social hall on the second floor. Louis Bauer's son Irvin sold the store in 1943, and it has since been razed. (BGSTMHS.)

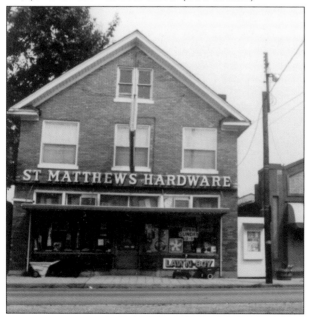

St. Matthews Hardware Store. Located just east of the Bauer Bros. grocery store on Shelbyville Road, the St. Matthews Hardware Store rivals Plehn's Bakery as the oldest surviving commercial building in downtown St. Matthews that is still being used for its original purpose. Constructed in the 1920s by George John Wurster, who died in 1941, it was purchased by his bookkeeper, George Hammer, and has been operated by the Hammer family ever since. (BGSTMHS.)

PALMER ASBESTOS & RUBBER COMPANY. Founded by Englishman Lawrence Palmer-Ball in 1930, the Palmer Asbestos and Rubber Company was located along the north side of Westport Road west of St. Matthews Avenue. It was the only true industry in St. Matthews, and its 100-foot-tall brick smokestack was visible from almost every part of the community. Most of the company's products were bought by the Palmer Equipment Company of Chicago, and the plant, now called Palmer Products, is still operating in 2015. (BGSTMHS.)

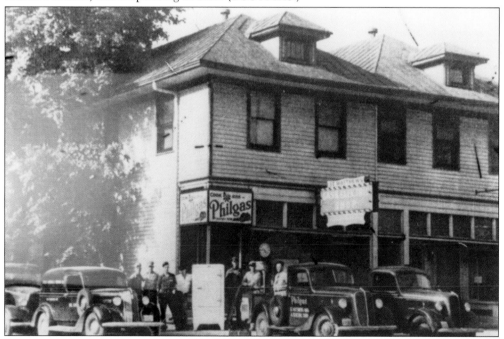

BUTLER PLUMBING AND HEATING COMPANY. Another important business in St. Matthews for many years, Butler Plumbing and Heating was established in 1926 when J.J. Butler Jr. took over his sisters' dry-goods building for his plumbing business. In 1929, he expanded by opening a subsidiary, the St. Matthews Gas and Electric Shop, which sold appliances. In the 1940s, he was among a group of business leaders pushing for the incorporation of St. Matthews. (BGSTMHS.)

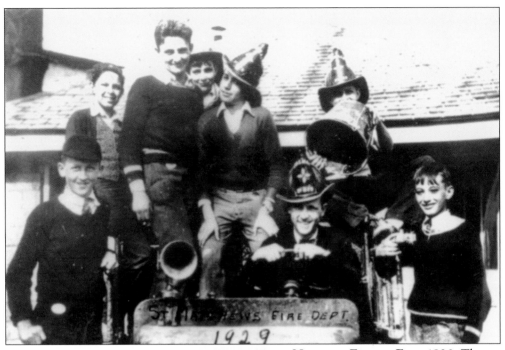

NEWSBOYS FOUGHT FIRE, 1930. The St. Matthews Fire Department was a volunteer organization at this time, and young boys, known as carriers, often stayed in the station overnight. Early on a Sunday morning in 1930, a house on Ridgeway Avenue, not far from the fire station on Breckenridge Lane, caught fire. None of the adult firefighters were on hand, so the boys went over and used chemical pumps and formed a bucket brigade to get water on the blaze. (BGSTMHS.)

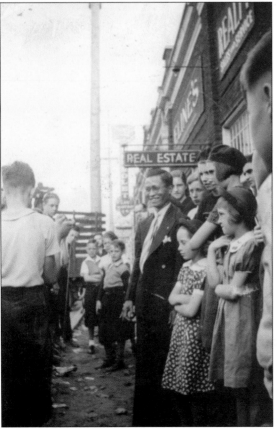

JAPANESE YO-YO SALESMAN, C. 1935. About 1935, a Japanese yo-yo salesman appeared on Frankfort Avenue, not far from the Point, and demonstrated the tricks one could learn to do with a yo-yo. It is unknown how many he sold, but, as the photograph suggests, he attracted a sizeable crowd. (Ellen Kaelin Venhoff.)

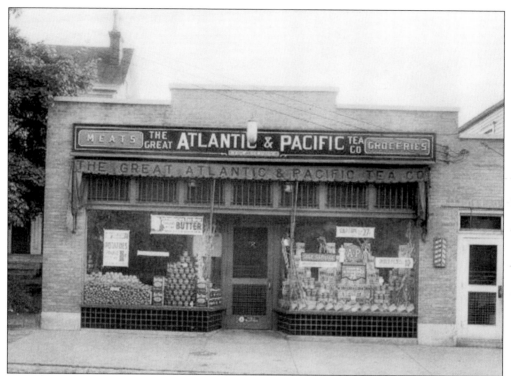

A&P Market, 1934. The A&P grocery store was located at 3814 Frankfort Avenue when this photograph was taken. By 1941, it had moved to a larger store at 3726 Lexington Road, but a major fire in May 1945 destroyed the store and its contents. A much larger store was built at 3929 Shelbyville Road and opened with great ceremony in May 1946. (SMCC.)

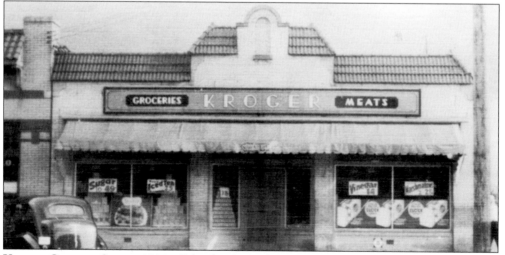

Kroger Grocery Store, 1930s. Like the A&P, the Kroger grocery store has bounced around St. Matthews over the years. During the 1930s, it was located next door to the A&P, at 3816 Frankfort Avenue. By 1941, it had moved to 3721 Lexington Road, just east of the Vogue Theater. It remained on Lexington Road until at least 1980 and soon thereafter moved to the Shelbyville Road Plaza. As of 2015, the St. Matthews Kroger is on Hubbards Lane just north of the railroad tracks. (SMCC.)

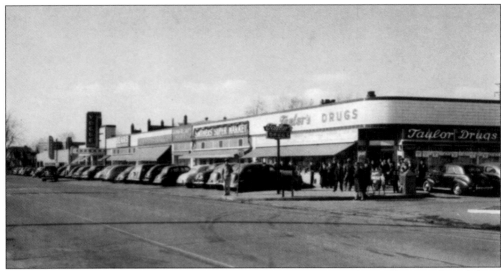

TAYLOR TRIANGLE, 1940s. What was known as the Taylor Triangle was a collection of retail shops and the Vogue Theater that filled up the triangular space formed by the meeting of Frankfort Avenue and Lexington Road. The Taylor Drug Store anchored one end of the triangle, while the Vogue dominated the other end. Sears and Kroger can be identified in between. These two places were landmarks in downtown St. Matthews for about 50 years, between 1940 and 1990. (BGSTMHS.)

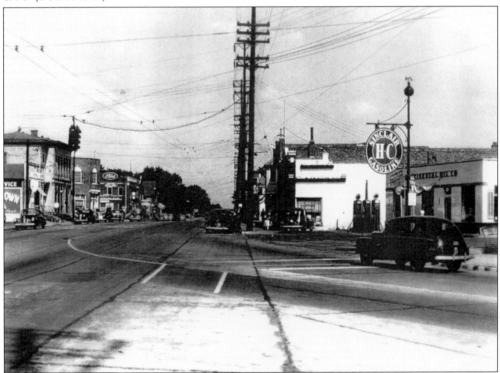

SINCLAIR GAS STATION, 1930s. Along with agencies such as Eline's that sold and repaired automobiles, there was also a need to fuel them, and this Sinclair station, located at the junction of Frankfort Avenue and Lexington Road, was one of several in the St. Matthews area. (SMCC.)

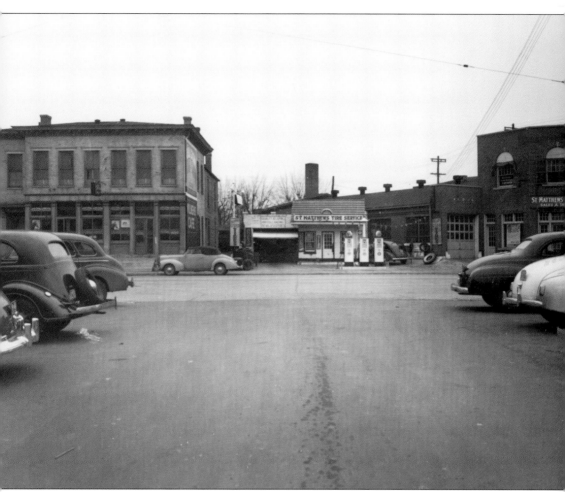

St. Matthews Tire Service. Another automotive-related business was the St. Matthews Tire Service (which also sold gasoline), located on Shelbyville Road opposite Meridian Avenue. Plehn's Bakery is at the far left in the photograph, taken about 1940. (SMCC.)

EARL HEWELL TRAILER DISPUTE, 1945. Earl Hewell ran an automobile-service shop at 3702 Lexington Road in 1944, when this photograph was taken. He applied to the city for permission to place several trailers on his property, citing the need for returning veterans to have access to economical housing. His appeal to patriotism fell flat, however; neighbors complained about the kind of people who might live there, and the city turned down his request. (JCHPA.)

SOUTHWESTERN BELL TELEPHONE COMPANY. As residential telephone service increased greatly during the 1920s, the need for a local substation became apparent in St. Matthews. This photograph was taken in 1947, but the telephone building at 111 Bauer Avenue dates to the 1930s. (JCHPA.)

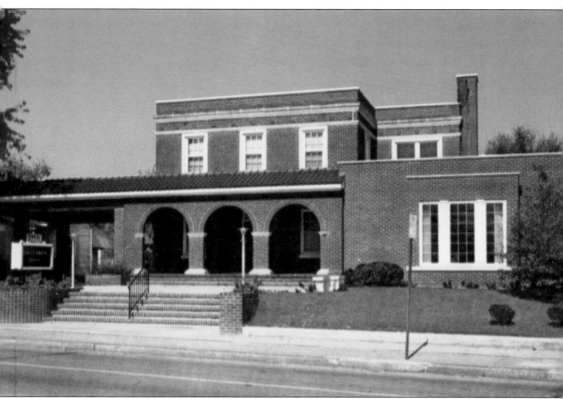

RATTERMAN FUNERAL HOME. The first funeral home in St. Matthews, Ratterman's, was originally called the St. Matthews Funeral Home, even though it was owned by the Ratterman family. The family put their own name on the business in the late 1940s, and it remains at the same location, 3711 Lexington Road, though the building has been altered beyond recognition. (BGSTMHS.)

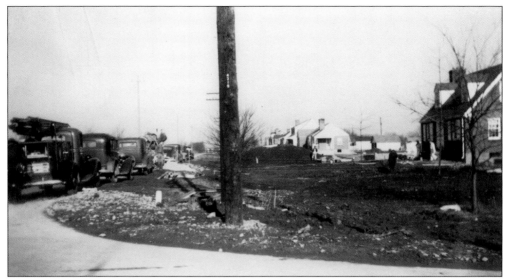

HUBBARDS LANE, LOOKING NORTH FROM WESTPORT ROAD, 1941. In 2015, Hubbards Lane north from Westport Road is almost completely residential. In 1941, that residential development was just getting under way, as shown by the houses under construction, the workers' cars parked along the road, and debris lying around. (JCHPA.)

SHELBYVILLE ROAD, LOOKING EAST, 1930s. In the mid-1930s, Shelbyville Road had practically no development of any kind east of Holy Trinity Church on the north and Tony Eline's home on the south. But, in this photograph, one can see that the road has become a divided four-lane thoroughfare in clear anticipation of what would come in the next 20 years. (SMCC.)

Six

Sports and Leisure

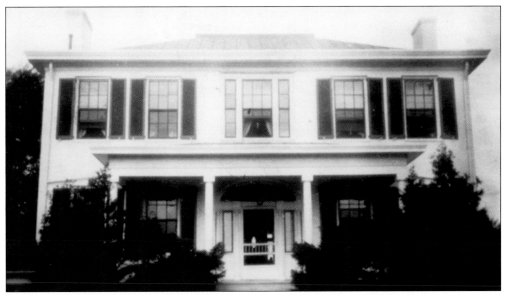

Woodlawn Race Course. In 1860, Woodlawn Race Course opened in St. Matthews northeast of the Point and south of Westport Road. It was, by all accounts, a fine track, but the Civil War and its aftermath spelled financial doom for Woodlawn, and it went bankrupt and was sold at auction in 1872. Its principal legacy is the Woodlawn Vase, a sterling-silver trophy that since 1917 has been presented to the winner of the Preakness. There are no surviving photographs of the racetrack, but this photograph features a house that was part of the Woodlawn clubhouse. After the race course closed, the Arterburn family owned the house for more than 50 years until it was sold to a Louisville doctor, Roy Moore, for $25,000 in 1925. (Bob Moore.)

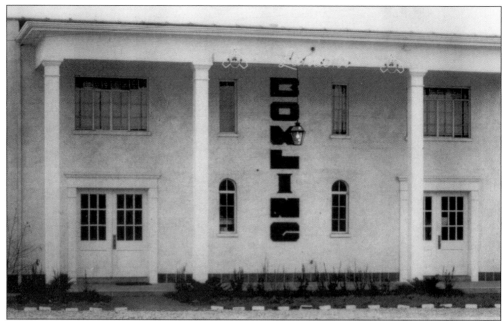

LANDOHR BOWLING ALLEY. Located at 4160 Shelbyville Road, just west of Hubbards Lane, Bill Dohrman opened the Landohr Bowling Alley in 1941 and expanded it from 8 to 12 lanes in 1945. When it opened, it was surrounded by potato fields, but the city rapidly grew out to meet it. Landohr's remained a popular spot until 1959 and the opening of the larger and more modern Ten Pin Lanes a short distance farther east on Shelbyville Road. The bowling alley closed in 1965, and the site is now occupied by an automobile agency. (JCHPA.)

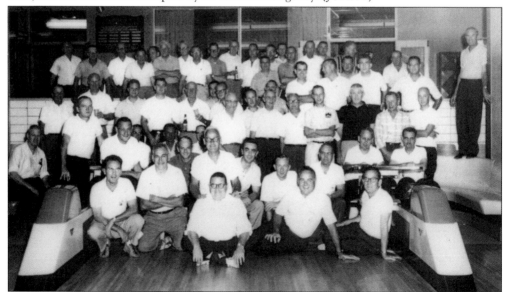

MEMBERS OF OUR LADY OF LOURDES BOWLING LEAGUE, 1960s. Churches and social organizations often sponsored teams in various athletic leagues. In addition to girls' softball and boys' baseball and football teams, bowling leagues were very popular as a means of forming strong parish bonds, and Our Lady of Lourdes Church had so many enthusiastic bowlers that it sponsored an entire league in the 1960s. (OLOL.)

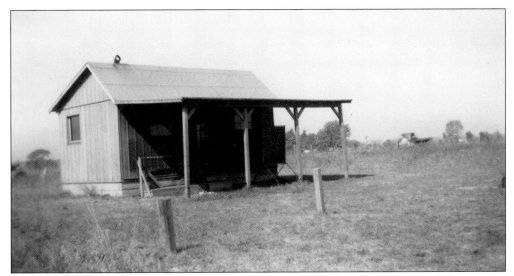

Skeet Club, Cannons Lane, 1940. An indication of the continuing agricultural character of St. Matthews, this lonely structure housed a skeet-shooting club, located near Cannons Lane in the vicinity of Big Spring Golf Club when this photograph was taken in 1940. (JCHPA.)

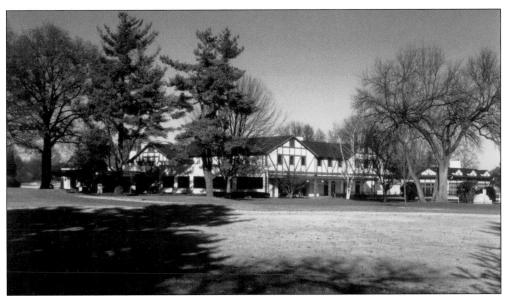

Big Spring Golf Club. A group of St. Matthews golf enthusiasts purchased 164 acres of land along the east side of Cannons Lane north of Dutchmans Lane in the mid-1920s, and George Davies, who had recently designed the Crescent Hill Golf Course, laid out an 18-hole course with consultative help from the Olmsted Brothers, the landscape firm that had designed much of the city park system for Louisville a generation earlier. The course layout has changed little since the club first opened, and the clubhouse, shown here, has always been a popular meeting place for members and guests. (BGSTMHS.)

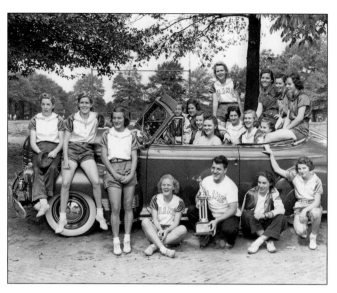

GIRLS' SOFTBALL TEAM, 1939. The Eline Chevrolet Company was a frequent sponsor of youth sports teams, and its 1939 girls' softball team was one of the best, winning the state championship and finishing second in the national tournament held in California. Among the girls in the photograph are Sara Eline, sitting in the driver's seat, Virginia Freven, sitting on the rear fender, and Eva Bauer, sitting in the back seat next to the unidentified blonde girl. (Sidney W. Eline Jr.)

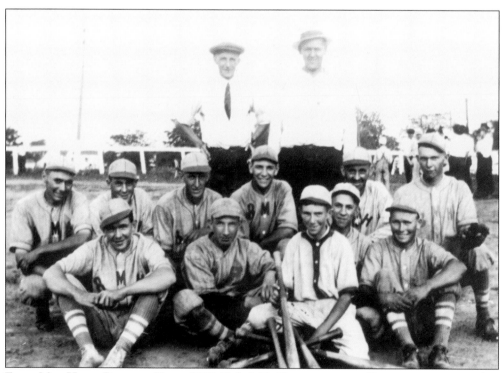

EIGHT-MILE HOUSE BASEBALL TEAM, 1918. Eight-Mile House was originally a store serving travelers on the Louisville and Lexington Turnpike and located just east of present-day St. Matthews. The name Eight-Mile House was later applied to a stone structure on Shelbyville Road that was a restaurant and dance hall from 1882 until fire destroyed it in 1930. Businesses like this often sponsored baseball and softball teams in local leagues. (Ochsner family.)

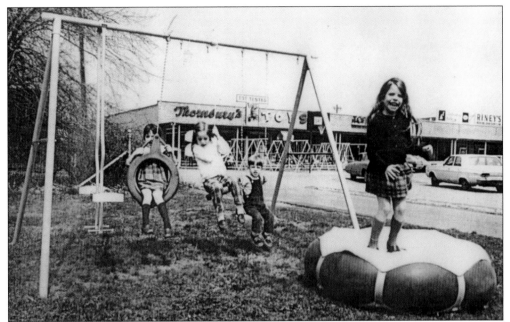

KIDS PLAYING AT THORNBURY'S TOY STORE, 1960s. Thornbury's Toy Store was a popular place in St. Matthews between the 1950s and 1990. Located at 4101 Shelbyville Road after 1960, the store placed many of its larger swing sets and other outdoor toys in front of the store so children could play on them, after which they would beg their parents to buy them. (SMCC.)

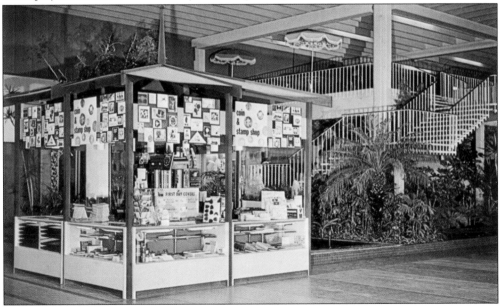

STUDIO STAMP AND COIN KIOSK, MALL ST. MATTHEWS. Soon after the construction of the Mall St. Matthews (then called simply the Mall), Richard Titzl moved his stamp business from a downtown Louisville location to the mall, where he sold his stamps from a small kiosk in the concourse. Titzl died in 1964, and his inventory was purchased by John Henry Ogden, a longtime St. Matthews resident. By 1971, Ogden had moved Studio Stamp and Coin to a shop at 3622 Lexington Avenue, where he continued to sell stamps and coins well into the 1980s. (Authors' collection.)

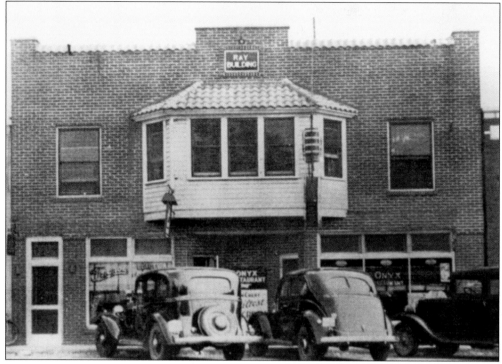

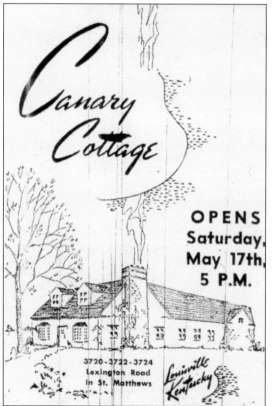

ONYX RESTAURANT IN RAY BUILDING. The Ray Building was located at 3812 Frankfort Avenue. For a few years in the late 1930s and early 1940s, it was the home of the Onyx Restaurant, a family-owned diner typical of the small businesses that dotted downtown St. Matthews during this period. After World War II, the owners of the Onyx tried their luck in downtown Louisville, but the restaurant remained open for only a short time. (BGSTMHS.)

CANARY COTTAGE OPENING ANNOUNCEMENT, 1947. The Canary Cottage was a popular restaurant that moved in 1947 from a downtown location to 3722 Lexington Road in the center of St. Matthews. The St. Matthews Business Association was first organized at the restaurant in 1955, and Friday fashion shows were popular for many years, as were the chicken croquettes. The restaurant closed in May 1969, and a variety of other restaurants and nightclubs occupied the space for several years. (BGSTMHS.)

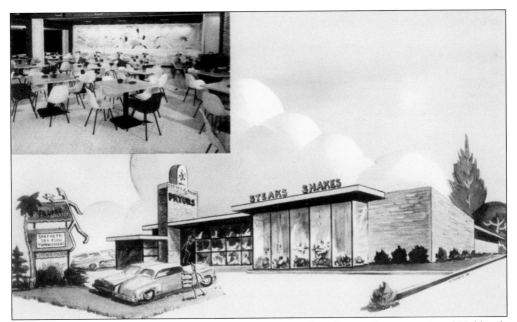

PRYOR'S DRIVE-IN RESTAURANT. Pryor's Drive-In, located at the southwest corner of Hubbards Lane and Shelbyville Road, was out on the edge of town when it opened in 1948. In the days before fast-food restaurants captured the market, Pryor's was a popular spot for high school students and young families. A gas explosion in December 1957 caused extensive damage to Pryor's, but it was rebuilt, became a family restaurant, and carried on until the late 1970s. (Authors' collection.)

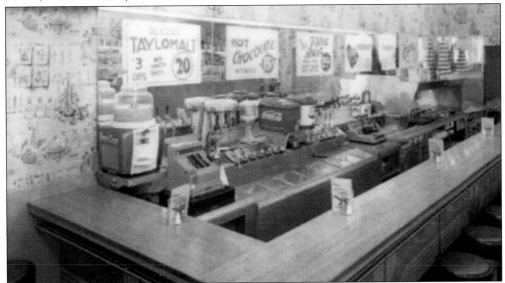

TAYLOR DRUG STORE SODA FOUNTAIN, 1950S. The Taylor Drug Store chain, founded in 1879 by T.P. Taylor, eventually grew to 50 stores in Kentucky and Indiana. The St. Matthews Taylor Drug Store was located near the Vogue Theater at 3747 Lexington Road from about 1940 to 1996, when Rite-Aid bought it out. Like many of drugstores in the pre–fast food era, it featured a popular lunch counter, or soda fountain, as they were called. A bank and several specialty stores presently occupy the site, known as the Vogue Center, after the popular movie theater that had been a St. Matthews landmark. (SMCC.)

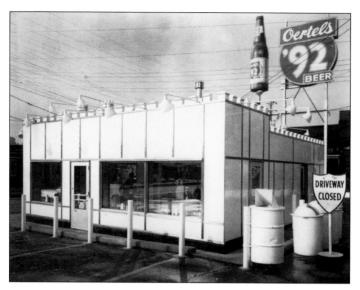

WHITE CASTLE EXTERIOR, WITH BEER SIGN. The iconic White Castle restaurant chain, begun in Wichita, Kansas, in the late 1920s, came to Louisville in the early 1930s and to St. Matthews in 1939, where it was located at 3809 Frankfort Avenue, a short distance west of the intersection with Chenoweth Lane. The Oertel's 92 beer sign may be related to Gerstle's, a popular bar at 3801 Frankfort Avenue. (White Castle Corporation.)

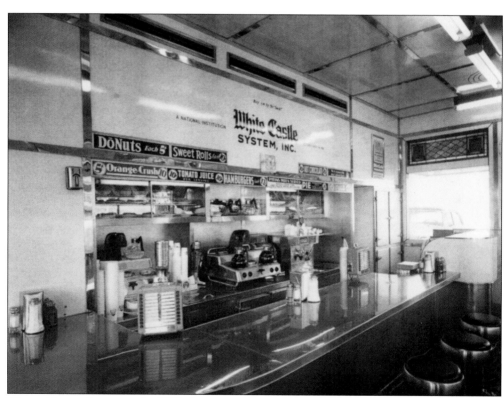

WHITE CASTLE INTERIOR. In 1969, the original Frankfort Avenue White Castle was demolished, and a new, larger version was constructed closer to the intersection. A one-story brick commercial building was also torn down, leaving more space for parking. White Castle remained a downtown St. Matthews landmark until 2002, when it was razed to make way for a new bank building. (White Castle Corporation.)

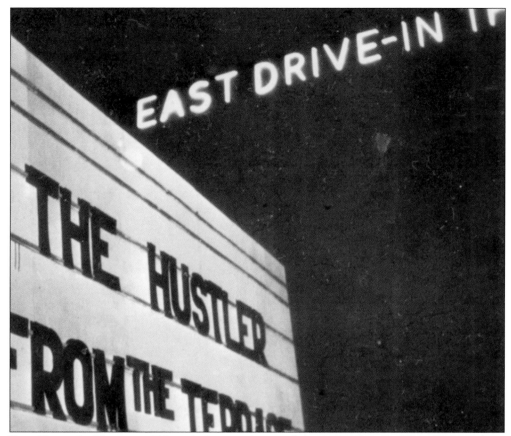

EAST DRIVE-IN THEATER. Although drive-in theaters first appeared in the United States about 1931, this was the first in Louisville when it opened in August 1941. At the time, it was simply the Drive-In Theater, but when others opened after the war, it became the East Drive-In Theater. For some 30 years, the theater was a popular spot on Shelbyville Road, near the Watterson Expressway, but by the early 1970s, the demand for more commercial space brought about its closing. The land it occupied became a parking lot for a shopping center. (WHS.)

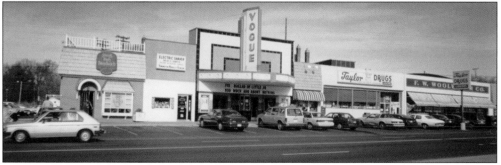

VOGUE THEATER, 1939. The Vogue opened in 1939 and quickly became the center of St. Matthews social life. Its Art Deco marquee was a landmark, and the theater developed a reputation in the 1980s and 1990s for showing independent films that the multiscreen complexes would not. Ultimately, the Vogue lost out to the larger cinemas and closed in 1998. Phyllis Kirwan spent $3.5 million to turn the area into an upscale shopping and dining venue called the Vogue Center, which opened in 2006. (JCHPA, photograph by Jeff McIntyre.)

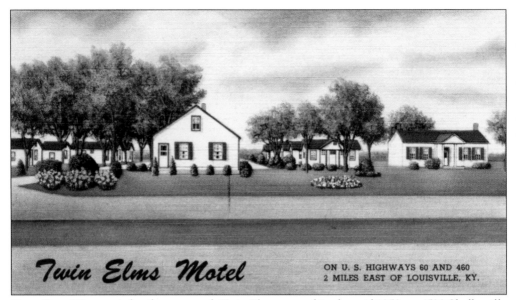

Twin Elms Motel

ON U. S. HIGHWAYS 60 AND 460
2 MILES EAST OF LOUISVILLE, KY.

TWIN ELMS MOTEL. A family-run motel, Twin Elms opened in the mid-1950s at 4520 Shelbyville Road. Soon, the owners added a mobile-home park with spaces for 44 trailers. City directories stop mentioning the motel in the 1970s, but the mobile-home park carried on until 1987, when the property was sold to Bluegrass Lincoln-Mercury, one of the many automobile agencies along Shelbyville Road. (Authors' collection.)

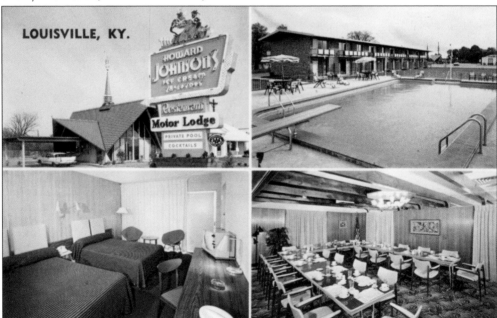

HOWARD JOHNSON MOTEL AND RESTAURANT. Owned and operated by Albert Entwhistle Sr., the Howard Johnson Motel and Restaurant opened in 1959, soon after the completion of the Watterson Expressway provided easy access. The motel was typical of the Howard Johnson chain, with a large pool and popular restaurant. The motel became a Days Inn in 1991, but the complex, except for the restaurant, which became an Outback Steakhouse, was razed in 2001. (Authors' collection.)

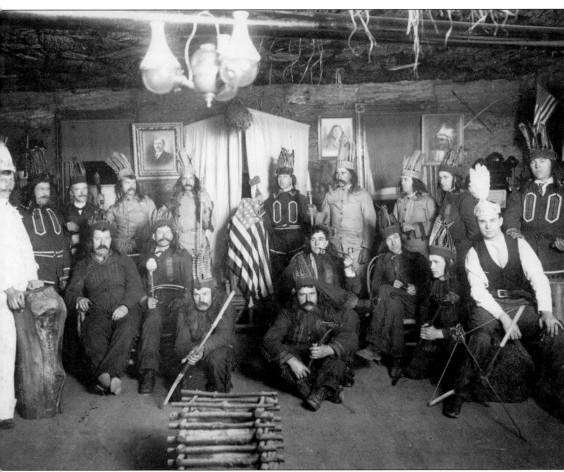

DEGREE TEAM OF METAMORA, No. 25. Metamora Tribe No. 25 was an affiliate of the Improved Order of Red Men, a fraternal organization begun during the American Revolution. The Metamora Tribe No. 25 was very active in Kentucky from 1899 to 1923, when it suspended activity. This image dates from 1905, when the tribe met over Frederick J. Edinger's feed store on Frankfort Avenue just west of Breckenridge Lane. The occasion that demanded costumes is unknown, but everyone seems to be having a good time. The Order of Red Men still exists, but there are no tribes in Kentucky. (BGSTMHS.)

AMERICAN LEGION, ZACHARY TAYLOR POST NO. 180. The American Legion, which was established soon after World War I, had its beginnings in Louisville in 1925. Early on, members met on Massie Avenue, and about 1941, they bought a house at 137 St. Matthews Avenue. This building, located behind a restaurant at 4848 Shelbyville Road, was constructed in 1956 at a cost of $125,000 and still serves the organization in 2015. (Authors' collection.)

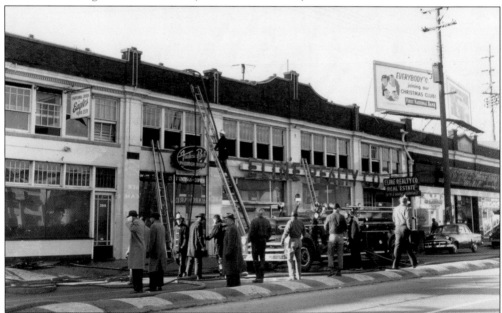

FIRE AT EAGLES' CLUB, 1958. The Eagles' Club of St. Matthews (FOE Aerie 2379) was, in the 1950s, one of the largest fraternal organizations in the community. Oriented more toward social camaraderie than community service, the Eagles, then a nonsectarian but whites-only club, enjoyed getting together at their club located on the second floor of the Eline Building at 3912 Shelbyville Road. On January 3, 1958, a gas-heater fire caused some $65,000 in damage. The St. Matthews Eagles aerie no longer exists, but there are Eagles in Louisville and Jeffersontown. (Sidney W. Eline Jr.)

St. Matthews Women's Club. The St. Matthews Women's Club was founded in 1937 and moved into this building at 4124 Shelbyville Road in 1948. Members met there for many years, presenting dramatic productions on the small stage and doing many different kinds of charitable work for troops during wartime, the library, and the school system. Membership declined sharply during the 1980s and 1990s. The building had outlived its usefulness by 2007 and was demolished in 2014. (Authors' collection.)

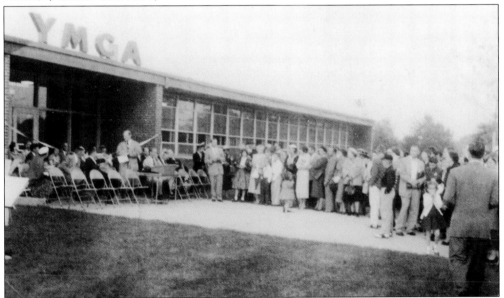

St. Matthews YMCA, c. 1955. First established in an old house at St. Matthews Avenue and Westport Road in 1948, the St. Matthews YMCA grew quickly and by 1953 clearly needed new and larger facilities. In 1955, a new YMCA opened at 4311 Norbourne Boulevard, complete with gym, craft rooms, and a kitchen. In 1987, the St. Matthews YMCA moved to northeastern Jefferson County to keep up with demographic changes and the need for even more space. The YMCA on Norbourne was razed, and townhouses now occupy the site. (From *150 Years: The YMCA of Greater Louisville*.)

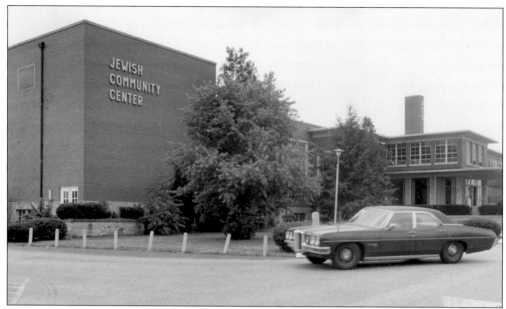

JEWISH COMMUNITY CENTER, 1955. The YMHA (Young Men's Hebrew Association) had been serving the Jewish community since 1890, but after World War II, more Jewish families were moving out to the east end of the city. Since the YMHA building at Second and Jacob Streets was becoming obsolete, the decision was made to construct a modern facility at 3600 Dutchman's Lane, convenient to the area where families were moving and the new Watterson Expressway. In 1955, the new Jewish Community Center (the name change was part of a national trend) opened. Designed by the noted architectural firm of Joseph & Joseph, the $1 million building boasted many nice features, including a gym, fitness center, classroom space, and an excellent array of outdoor swimming pools. The JCC continues to operate at this location and has also become known for CenterStage, its community theater. (Jewish Community Center.)

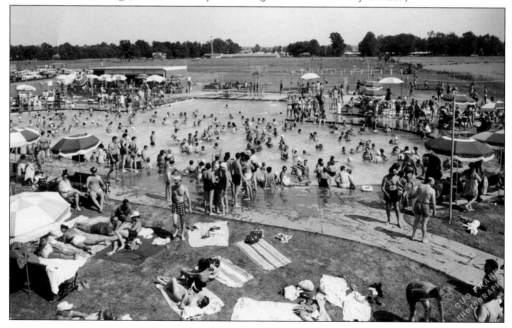

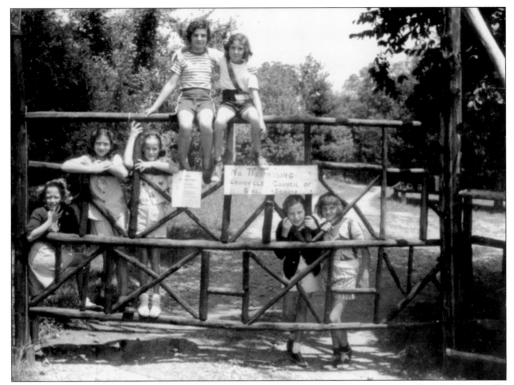

GIRL SCOUTS AT CAMP ENTRANCE, 1950S. The Girl Scouts were first organized in the Louisville area in 1923, with the support of most of the prominent women's professional and social clubs. The Girl Scouts quickly became very popular, and by the fall of 1924, there were 25 troops in the city. In 1930, Camp Shantituck, located near Shepherdsville, was purchased as a permanent Scout camp. Pictured here are a large number of Louisville and St. Matthews Scouts posing on the main gate to the camp in the 1950s. (Girl Scout Council of Kentuckiana.)

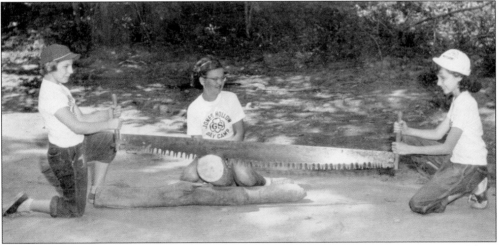

GIRL SCOUT TROOP 232 AT CEDAR POINT, 1967. Troop 232 was a St. Matthews troop, and here three Scouts from the troop are practicing the art of sawing large logs. From left to right, the intrepid woodworkers are Marilyn Middlestadt, Patricia Johnston, and Bonnie Rieser. (Girl Scout Council of Kentuckiana.)

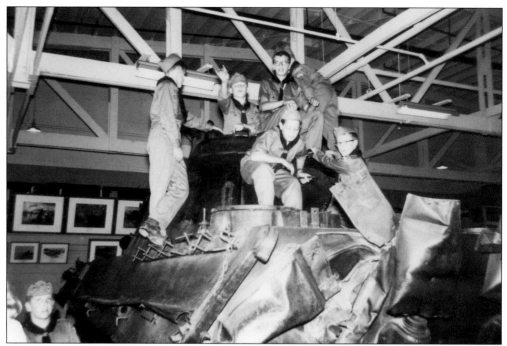

Boy Scouts of Troop 325 at Patton Museum. St. Matthews has been home to several Cub Scout packs and Boy Scout troops over the years, including Troop 315 at Harvey Browne Memorial Presbyterian Church, Pack 122 at Greathouse School, and Pack 312 at Stivers School. Here, scouts from Troop 325, based at Our Lady of Lourdes Church, visit the Patton Museum at Fort Knox, Kentucky, in the 1960s. (Tom Zehnder.)

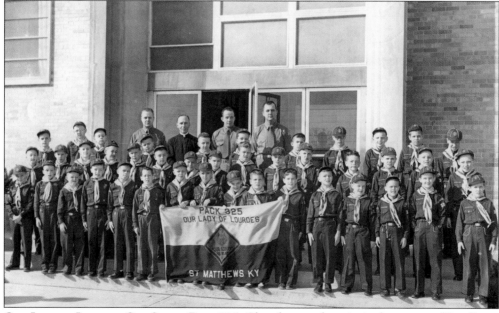

Our Lady of Lourdes Cub Scout Pack 325. Churches are the principal sponsors of Boy Scout and Girl Scout troops and their younger versions, Cub Scouts and Brownies. Here is the Cub Scout pack that Our Lady of Lourdes sponsored in the 1960s. (OLOL.)

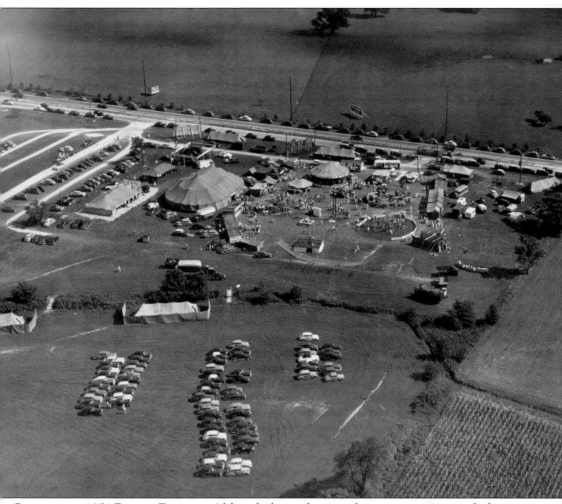

OVERVIEW OF 1951 POTATO FESTIVAL. Although the production of potatoes was in steep decline by 1947, community leaders decided to inaugurate an annual Potato Festival in 1947. This would run for four days in July and coordinate with the yearly potato market. It was organized as a traditional community festival, with rides, food, games, displays, and entertainment. The festival was held on Shelbyville Road near the East Drive-In Theater on land that was still largely used for growing potatoes and other produce. Funds raised at the festival were earmarked for the purchase of park improvements and playground equipment. The festival ran for seven years, but by 1954, potatoes were grown on only 750 acres in Jefferson and Oldham Counties, and the St. Matthews Produce Exchange building had been sold to a lumber company. The festival was changed to a more generic community festival but lasted only one more year. (Dan Gray.)

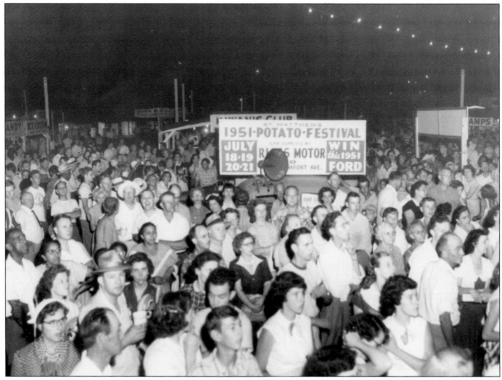

CROWD AT 1951 POTATO FESTIVAL. At the height of its popularity, the Potato Festival drew large crowds and hosted well-known entertainers such as Pee Wee King and the Golden West Cowboys. A competitive flower show, organized by the St. Matthews Women's Club, and a parade were also major attractions. (Sidney W. Eline Jr.)

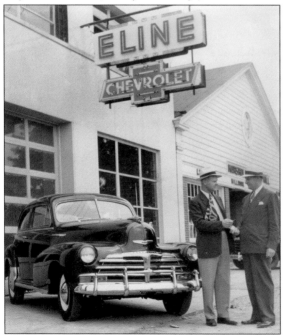

RAFFLE WINNER AT 1949 POTATO FESTIVAL. The festival featured many ways in which visitors could win prizes, but the main event was a raffle for a new car. Here, Bud Eline of the Eline Chevrolet Company stands next to the 1949 Chevrolet won by Tom L. Ball. The raffle earned more than $3,500 for the festival's causes. (Sidney W. Eline Jr.)

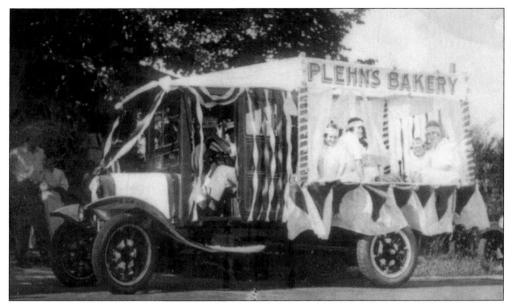

PLEHN'S FLOAT IN 1920S FESTIVAL PARADE. Plehn's Bakery, which moved from downtown to its present Shelbyville Road site in the center of St. Matthews in 1924, quickly became involved in community activities. A Plehn's float participated in a 1926 parade through St. Matthews. Kuno Plehn is driving the truck, and riding on the float are, from left to right, Mamie Habich, Mary Bowling Wallitch, and Martha Ann Bowling. (Bernie Bowling Jr.)

COT HAYNES'S ACCORDION BAND, 1951. Cot Haynes was a local music teacher who worked for Shackleton's, a music store that was one of the early tenants in the Mall on Shelbyville Road. Haynes had a peculiar fondness for the accordion, and in 1951, he created this children's accordion band. He later established an accordion studio in downtown Louisville. (Al Ring.)

TOM ZEHNDER ON A PONY, C. 1952.
Sometimes the simplest and most pleasurable forms of leisure are those that families make for themselves. Between the 1920s and 1950s, it was not uncommon for itinerant entrepreneurs to visit neighborhoods with a pony and invite residents to purchase a photograph of their children sitting on it. Young Tom Zehnder is seated comfortably on one such pony in front of his St. Matthews home about 1952. (Tom Zehnder.)

CONSTRUCTION OF ST. MATTHEWS COMMUNITY PARK, C. 1960. Although the Potato Festival raised money for a playground and the purchase of playground equipment during the late 1940s and early 1950s, St. Matthews had to wait longer before a real park was built. Here, an unidentified town official watches as workers construct a park near the former site of the East Drive-In on Shelbyville Road. (Ken Draut.)

Seven

THE POSTWAR BOOM

MAP OF ST.
MATTHEWS AND
NEIGHBORING TOWNS,
1950s. This section
from a standard road
map shows the limits
of the community
of St. Matthews,
including the smaller
independent towns,
after annexation. The
city of St. Matthews
initially consisted
of only three square
blocks, but Mayor Jim
Noland engineered
a major annexation
in 1953 that added
about 5,000 residents,
and St. Matthews
became a fourth-
class city in 1954.
(Authors' collection.)

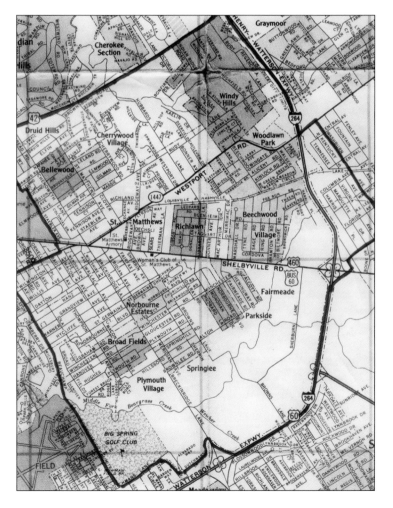

JIM NOLAND, FIRST MAYOR OF ST. MATTHEWS, 1950–1958. In the 1940s, Jim Noland (1895–1960) became one of St. Matthews's community leaders. He helped defend the town against possible annexation by the City of Louisville and was chairman of the five-member board that incorporated St. Matthews as a sixth-class city in 1950. As a result, he was immediately chosen to serve as mayor. Mayor Noland served through September 1958 without pay, when illness forced his resignation. (Al Ring.)

KOSTER-SWOPE BUICK ADVERTISEMENT. Fred Koster and Darrell Swope both had experience in automobile sales when they opened their lot on East Broadway in the mid-1940s. They acquired a Buick dealership and land at Bauer and Frankfort Avenues for their St. Matthews location in 1949. In the late 1970s, it became Tom Payette Buick and Jaguar. Advertising postcards such as this were sent to remind customers to bring their cars in for service. (Authors' collection.)

ST. MATTHEW FEED AND SEED ADVERTISEMENT. George Washington Weaver opened a feed store in the early 1920s on the corner of Gilman Avenue and Chenoweth Lane. Eventually, it added seed and hardware for the many farmers in the community. Raymond W. "Red" Davis acquired the store in 1950 and built the current store at 225 Chenoweth Lane in 1958. (Al Ring.)

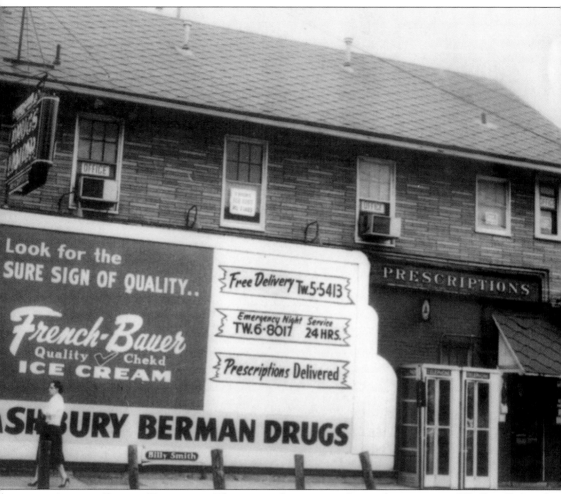

ASHBURY-BERMAN DRUGSTORE. There was a drugstore on the southeast corner of Shelbyville Road and Breckenridge Lane from 1915 to the 1980s. Various owners such as Manneman, Buschmeyer-Ogden, and Whitehead preceded Ashbury-Berman, who began operating the store in 1949. The building has been razed, and the space is now the parking lot of St. Matthews Station, a small commercial area featuring Molly Malone's, an Irish-themed bar and restaurant. (BGSTMHS.)

POOKMAN'S DRUGSTORE ADVERTISEMENT. There has also been a drugstore on the corner of Bauer Avenue and Lexington Road for many years. Ben Pookman operated a drugstore in downtown Louisville for 26 years before opening this St. Matthews store in 1951. (Al Ring.)

BROWN'S JEWELRY ADVERTISING POSTCARD. Advertising postcards such as this one for J. Brown's jewelry store were very common in the 1940s and 1950s. The store was located at 3708 Lexington Road. It opened in 1951 just east of Pookman's drugstore and remained open for more than 40 years. (BGSTMHS.)

EMORY'S BABY AND JUNIOR SHOP. In May 1945, the A&P at 3726 Lexington Road, across from the Vogue Theater, burned to the ground. The grocery store relocated to 3814 Frankfort Avenue, and a shopping strip took its place. In December 1946, Byck's ladies clothing store and Emory's were the first to open there. (SMCC.)

SHOWERS' BOY'S STORE. Henry Showers opened his men's and boys' clothing store in 1941 next to Plehn's Bakery at 3930 Shelbyville Road. This was the place to go for special occasion clothes, school uniforms, and official Boy Scout supplies. It remained a high-end clothing shop until it closed in 2008. (Al Ring.)

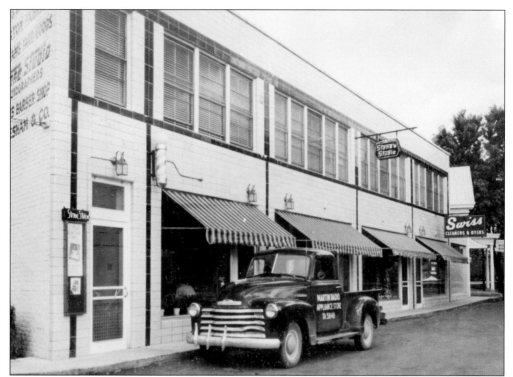

FAIRMEADE ROAD PROFESSIONAL BUILDING, 1953. Located just south of Shelbyville Road, this building housed small service businesses on the first floor and professional offices on the second floor. Business centers such as this reflected the continuing residential and commercial growth of St. Matthews farther east along Shelbyville Road. (BGSTMHS.)

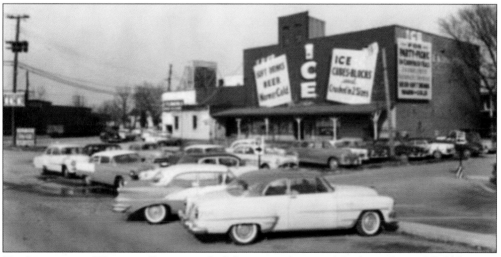

THE ICEHOUSE ON WESTPORT ROAD AND ST. MATTHEWS AVENUE. Merchants Ice and Cold Storage, begun in 1906, had several locations around Louisville. The St. Matthews branch was opened in 1908 and provided ice service and storage, especially for the St. Matthews Produce Exchange, located across Westport Road and the railroad tracks. When the demand for block ice lessened, the icehouse became a place to purchase cold drinks. It was razed in 1952 to provide parking for the new Bacon's store. (BGSTMHS.)

PEARSON'S FUNERAL HOME. In 1848, Lorenzo Dow Pearson opened a cabinet shop at Second and Main Streets in downtown Louisville. He began making wooden coffins as a sideline but had to have a ready inventory. Very soon he became known as an undertaker. He moved his business several times over the years. His son Edward became a leader in securing training and licensing for embalmers. When the horse-drawn funeral gave way to the automobile, Edward designed a wood-paneled hearse to fit on an automobile body. In 1924, the mortuary moved to Old Louisville, and in 1951, the St. Matthews Pearson's opened on Breckenridge Lane. The business has been owned by five generations of the Pearson family. (Above, BGSTMHS; below, Al Ring.)

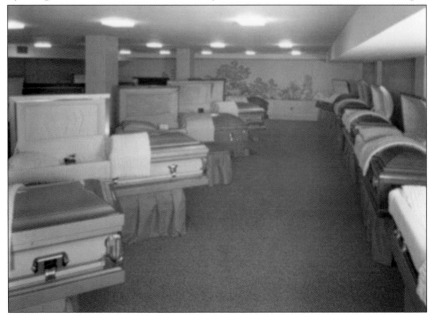

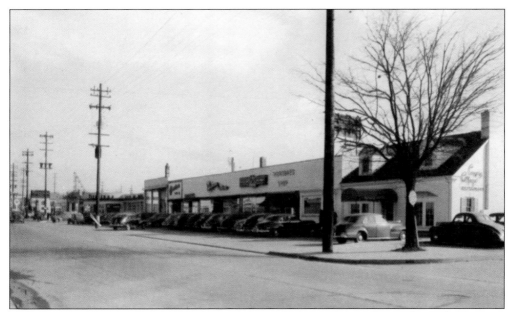

STRIP MALL ACROSS FROM THE VOGUE CENTER. In the space that was once the Evelann movie theater in the 1920s and the burned-out A&P in the mid-1940s, this shopping area opened in 1946 with Byck's Clothing Store and Emory's Baby and Junior Shop. The Canary Cottage, which opened in 1947, can be seen at the far right of the photograph. (BGSTMHS.)

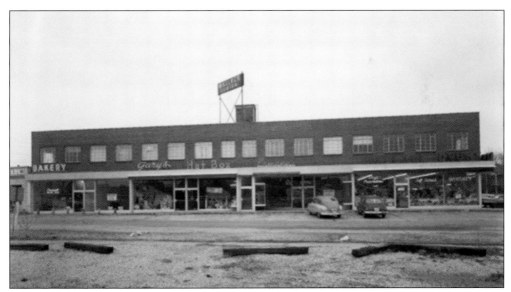

WALLACE CENTER. St. Matthews, growing in leaps and bounds, needed more stores all the time. This small center on Wallace Avenue just off Lexington Road opened in 1951. Xavier Nally's barbershop, visible on the left at the north end, is still there in 2015. These other shops, though memorable to people who grew up in St. Matthews in the 1950s and 1960s, have changed many times over the decades. (U of L.)

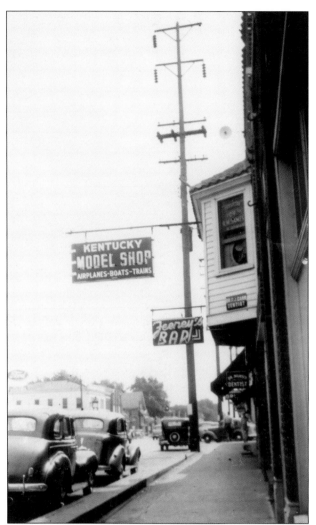

KENTUCKY MODEL SHOP, 3812 FRANKFORT AVENUE. The end of World War II gave many people spare time and extra money to pursue hobbies. The Kentucky Model Shop opened in 1945 and was at the Frankfort Avenue location until the Wallace Center opened in 1951, when owner Hunter Look moved to the Wilmington Avenue end of the center. In 1972, it moved to 3700 Lexington Road, and by 1975 it had gone farther east to Hikes Lane. (BGSTMHS.)

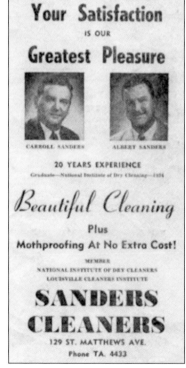

SANDERS CLEANERS ADVERTISEMENT. I.J. Sanders opened his cleaners in 1945 on Shelbyville Road, then Frankfort Avenue. Bacon's bought the property to build a new department store in 1952. Sanders moved around the corner to St. Matthews Avenue and remained open until 1969. (SMCC.)

BERNIE BOWLING SR., MAYOR, 1958–1984. St. Matthews businessman, owner of Plehn's Bakery, civic leader, and civil engineer, Bernie Bowling Sr. was appointed mayor of St. Matthews in 1958. He used his engineering background to tackle drainage and flooding problems that plagued many streets in St. Matthews (see page 112) and laid the groundwork for future economic development. He served as mayor for 26 years, the first 21 without pay, until his death in 1984. (Al Ring.)

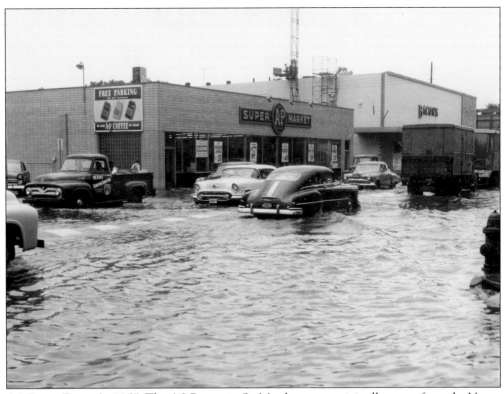

A&P AND BACON'S, 1955. The A&P store in St. Matthews was originally across from the Vogue Theater on Lexington Road. A fire in 1945 necessitated this newly built store. In August 1953, when Bacon's opened in St. Matthews, it was one of the last stand-alone suburban department stores in the area, as shopping centers and malls became increasingly popular. (BGSTMHS.)

BACON'S PARKING LOT. Although Bacon's was located directly on Shelbyville Road in downtown St. Matthews, its large parking lot behind the building and the lack of parking on Shelbyville Road meant that customers entered at the rear of the store. Bacon's was bought out by Dillard's in 1998 and moved to Mall St. Matthews. Other businesses have since occupied the Bacon's building. (BGSTMHS.)

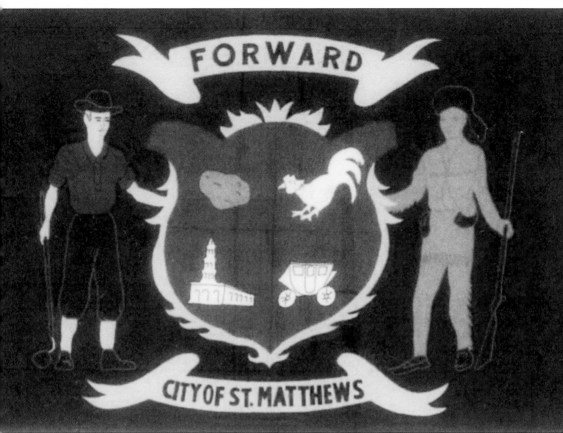

CITY OF ST. MATTHEWS FLAG. In 1960, the city flag was designed by contest winner Stephanie Baldyga, then a 13-year-old eighth-grader at Our Lady of Lourdes School. It shows an early pioneer, a potato farmer, a stagecoach, a fighting cock (a "sport" at one time popular in the area), and St. Matthew's Episcopal Church. (Al Ring.)

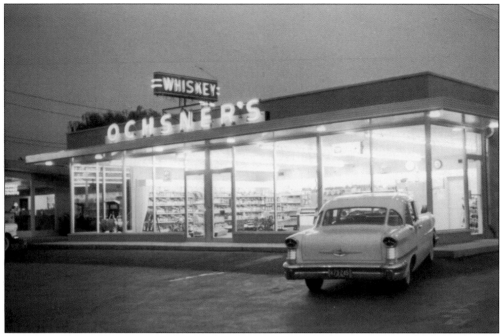

OCHSNER LIQUOR STORE. The Ochsner family was a vital part of the community from the late 19th century. They first opened their garage in 1920 near what is now Oxmoor Mall but moved to its present location in 1937. In the 1950s, they built a new garage, which is still owned and operated by Mike Ochsner, and added a liquor store at the address that is now a Thornton's service station. (Mike Ochsner.)

STORES ON SOUTH SIDE OF SHELBYVILLE ROAD. These storefronts on Shelbyville Road just east of Breckenridge Lane were built in the 1920s, when the community was beginning to grow. Shown here in the 1950s and still valuable commercial property, they have housed an assortment of clothing shops, groceries, specialty, and drugstores that demonstrate the ever-changing nature of retail establishments. (Bernie Bowling Jr.)

CHISM HARDWARE. In what had been a Steiden grocery store, the Chism family opened a hardware store on Shelbyville Road and Willis Avenue in 1952. Even though St. Matthews Hardware was only a block away, both stores did well until the 1990s, when the big chain building-supply stores began to draw customers away. Chism's Hardware closed, and the building was sold to a restaurant in 1997. (Al Ring.)

SHELBYVILLE ROAD PLAZA. In November 1955, Shelbyville Road Plaza opened with 27 stores and parking for up to 2,000 cars. Robert W. "Buck" Marshall, a local real estate developer, had acquired the land from the Meisner family, which had farmed potatoes there since 1907. Among the original stores at the shopping center, which cost $2.5 million to build, were Levy Brothers, Woolworth's, W.T. Grant, Taylor Drugs, Kroger, Highland Cleaners, and Schiff Shoes. (U of L.)

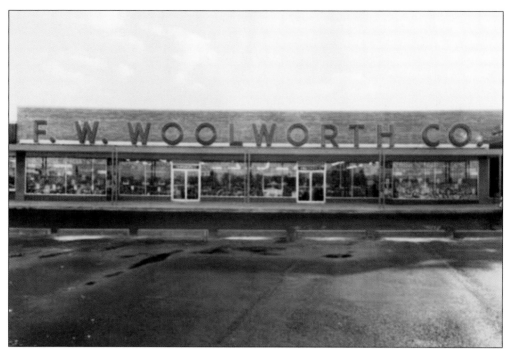

WOOLWORTH'S IN SHELBYVILLE ROAD PLAZA. F.W. Woolworth's five-and-dime had been a St. Matthews institution since the 1930s and was located in the heart of the downtown business district in the Taylor Triangle, along with the Vogue Theater. The company moved to this new, larger store in 1955 as many other businesses moved to strip malls and shopping centers. Eventually, Woolworth's became Woolco and opened a store farther east on Shelbyville Road. (U of L.)

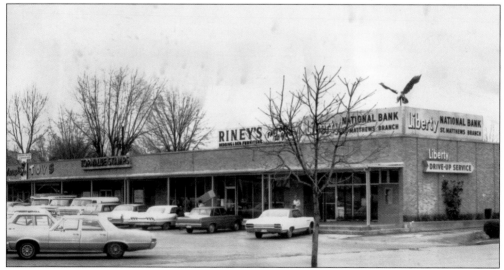

SHELBYVILLE ROAD SHOPPING STRIP. Thornbury's Toys and the Riney Bedding Company were the major tenants here. The Riney company began in 1929 in downtown Louisville. Like many other businesses, Riney's opened suburban locations such as this one on the site of the old Greathouse School on Shelbyville Road at Browns Lane. This small strip mall had four businesses that were well known in the 1960s and 1970s, but all have closed. Liberty Bank became Bank One and then Chase, which has rebuilt and is still at this site. (Sidney W. Eline Jr.)

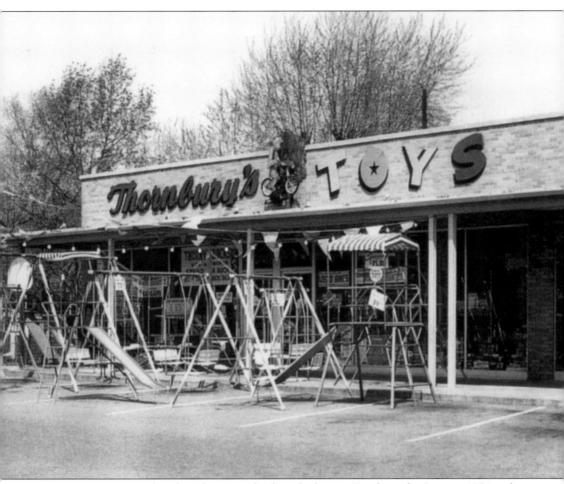

THORNBURY'S TOYS. Jim Thornbury began with a bicycle shop on Breckenridge Lane in 1954 and soon expanded to become a full-scale toy store. He began bike-safety classes, sponsored yo-yo contests and sports clinics, and became somewhat of a television personality. The Shelbyville Road store opened in 1960, with Thorny the monkey over the door, and remained open until 1990. (SMCC.)

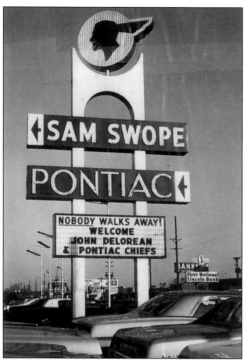

SAM SWOPE PONTIAC. Beginning with a Plymouth dealership in Elizabethtown, Kentucky, Sam Swope decided to move to St. Matthews and buy the Riggs Plymouth dealership at 126 Breckenridge Lane in 1960. In 1961, he was able to buy the Pontiac franchise where "nobody walks away." Automobile sales were skyrocketing at this time, and his new dealership became one of the largest on Shelbyville Road and in the region. Below, Swope (right) and the regional Pontiac director confer. (Sam Swope.)

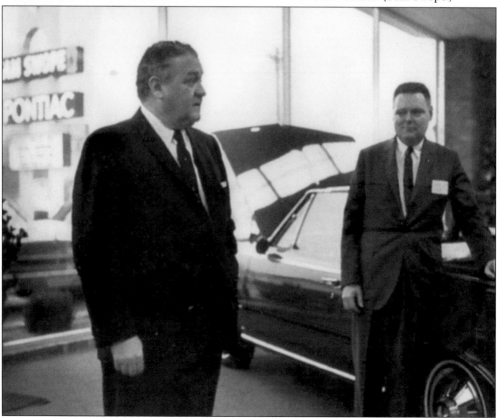

MALL ST. MATTHEWS. Mall St. Matthews began as the Mall, as it was the first enclosed shopping mall in Kentucky when it opened in 1962 with 50 stores. By 1969, there were 16 more stores. Department stores that moved from downtown Louisville, small shops, specialty kiosks, and a wide variety of other businesses made this *the* place to shop in the 1960s. When it opened, the Mall was anchored by Kaufman's at the west end and J.C. Penney at the east end, although over the years, many other stores have come and gone. (BGSTMHS.)

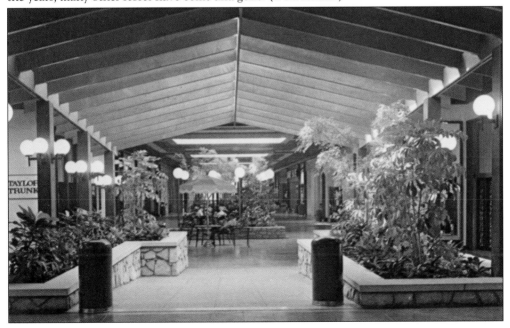

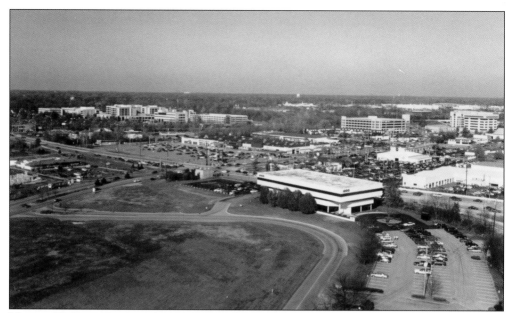

VIEW OF DUPONT SQUARE AREA, 1970S. The southern portion of St. Matthews lagged behind the rest of the community in commercial development; much of the area remained farmland well into the 1960s and 1970s. By 1969, however, as the two large hospitals were being built, Frank Metts and other developers looked at the potential for commercial growth. This view shows the new Baptist Hospital East on the left, the equally new Suburban Hospital on the far right, and Breckenridge Lane running horizontally across the middle. The beginnings of the DuPont Circle commercial district are visible around Suburban Hospital, but Beargrass Creek has prevented much development around Baptist East. (BGSTMHS.)

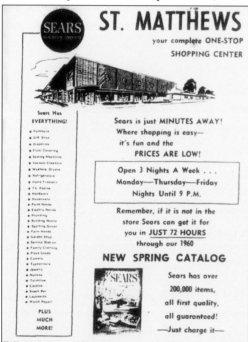

SEARS ADVERTISEMENT. Sears opened a small mail-order store on Lexington Road next to the Vogue Theater in 1939. In the 1950s, department stores began building larger facilities in the suburbs. Sears followed suit and built a larger store on property at Shelbyville Road and Thierman Lane on what had been farmland. The Washburn family had owned this land in the 19th century, but by the 1950s, the Seiderman family had farmed it for decades. Sears's $2 million store opened in October 1959 but had moved to Oxmoor Mall by 1987. (Al Ring.)

KENTUCKY FARM BUREAU, 1950S. Founded in 1919 as the voice of Kentucky agriculture, the Kentucky Farm Bureau continues to be the principal lobby for the state's farmers as well as one of their chief insurers. In 1948, the organization built the first major postwar office building in St. Matthews at 120 South Hubbards Lane just south of Shelbyville Road and behind Pryor's Drive-In Restaurant, constructed the same year. The building cost about $180,000 and served the farm bureau until the 1980s, when it moved to a new facility at 9201 Bunsen Parkway along I-64. The St. Matthews building was incorporated into Atria, a senior citizens' residence. (BGSTMHS.)

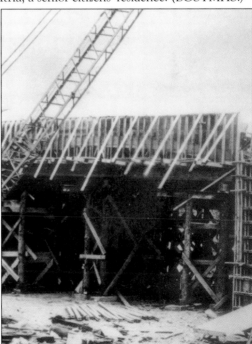

BUILDING I-64 THROUGH SENECA PARK. The interstate system begun in the 1950s had a terrific impact on St. Matthews's development. The community is bounded on the east by I-264 (the Watterson Expressway), which began as an outer beltway in 1948, while I-64, built during the 1960s, cuts across the southern part of the community. I-64 passes through some hilly parkland, as evidenced by this photograph of a tunnel under construction. (WHS.)

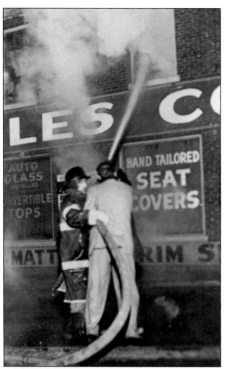

CONSOLIDATED SALES FIRE, 1954. In 1949, the discount department store Consolidated Sales opened on the corner of Chenoweth Lane and Frankfort Avenue in the space vacated by Haggard Motors. In December 1954, there was an unexplained but destructive fire, and the structure had to be demolished. White Castle, which shared the parking lot, eventually built a newer restaurant on the spot. Consolidated moved to the new Shelbyville Road Plaza. (Al Ring.)

RECORD DEPARTMENT IN CONSOLIDATED SALES. By the 1960s, rock 'n' roll had taken over the popular music scene. Every baby boomer, before they were known as such, had a stereo and a record collection. Many department stores, such as Consolidated Sales, had a sizable record department. (SMCC.)

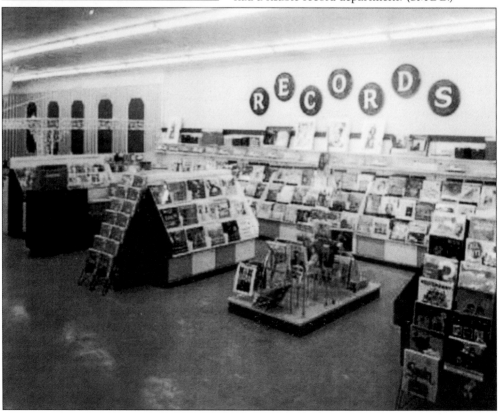

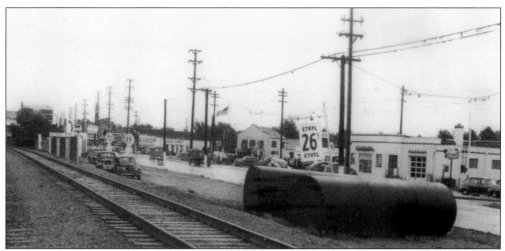

FRANKFORT AVENUE LOOKING EAST, 1948. The Louisville and Nashville Railroad tracks run alongside Frankfort Avenue from the Clifton neighborhood four miles west of St. Matthews to the intersection of Frankfort Avenue, Westport Road, and Chenoweth Lane, where the tracks turn to the northeast. This view, taken from the tracks, shows a cluttered Frankfort Avenue, about two blocks from the intersection, with gas stations and other small businesses and plenty of traffic. (JCHPA.)

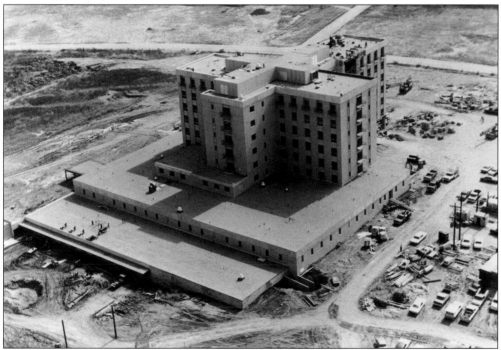

SUBURBAN HOSPITAL. St. Matthews had grown considerably in the 1950s and 1960s, yet there was no hospital nearby. In the fall of 1970, the Falls Region Health Council approved building not one but two hospitals to serve the area: Suburban in Dupont Square and Baptist East on Breckenridge Lane. Suburban was built by Extendicare, which later became Humana, and opened in 1975. Norton Healthcare acquired the hospital in 1998 and has since expanded it considerably. It is now called Norton Women's and Kosair Children's Hospital. (Norton HealthCare.)

BAPTIST HOSPITAL EAST. Consideration about building a satellite hospital to the aging Kentucky Baptist Hospital on Barret Avenue near downtown Louisville began in the mid-1960s, and St. Matthews was a logical contender for the new hospital since there was not one nearby and the area was growing rapidly. In 1970, the Falls Region Health Council approved plans for both Baptist Hospital East and Suburban Hospital. Baptist Hospital officials purchased 52.3 acres of land that had been part of the J. Graham Brown farm near I-64, between Breckenridge Lane and Browns Lane. Construction began on the $16.5-million hospital in 1972, and the first patients were admitted in March 1975. (Baptist Hospital East.)

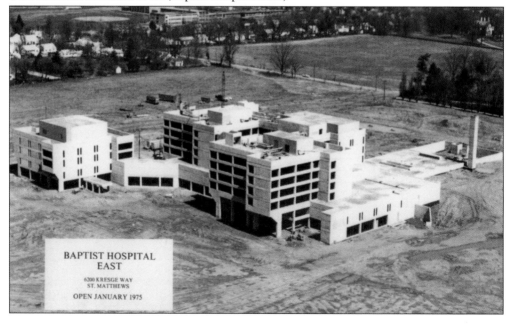

KAELIN'S MARKET AT WESTPORT ROAD AND FOUNTAIN AVENUE. Theodore and Evelyn Kaelin had several businesses in downtown St. Matthews. In 1952, they opened this small grocery in the northeast corner of St. Matthews that provided fresh meats and produce. It was one of the few businesses between St. Matthews and the end of Westport Road. In 1975, Kaelin's Grocery became Kaelin's House of Liquor and remained open until the late 1990s. (Ellen Kaelin Venhoff.)

CHENOWETH LANE LOOKING NORTH, 1975. The view down Chenoweth Lane gives a glimpse of early 1970s development in St. Matthews after Chenoweth Square opened in 1973. None of the original shops in the square still exist, but there are seldom lengthy vacancies. (BGSTMHS.)

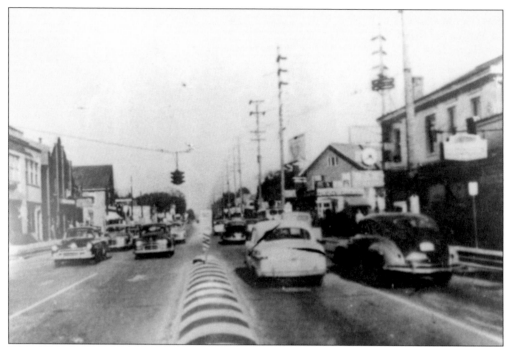

SHELBYVILLE ROAD FROM CHENOWETH/BRECKENRIDGE LANE. Pictured here in 1949 (above) and 1971 (below), Shelbyville Road from these perspectives provide an idea how the community had grown in the years after World War II. Most of the buildings on the right predate the war. Those on the left, except for Pete Hammer's St. Matthews Hardware, were built in the 1950s. Many of the businesses in the older buildings have changed, and both Bacon's and the A&P are no more, though the buildings continue to be desirable commercial property. The 1971 view is almost 50 years old—what will the next 50 years bring? (BGSTMHS.)

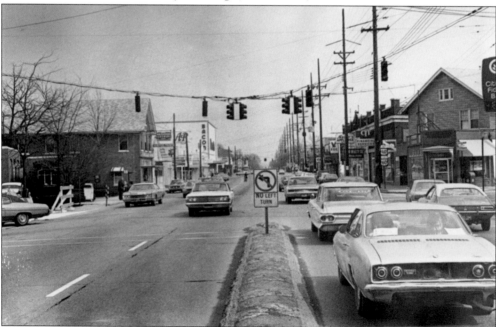

SUGGESTIONS FOR FUTURE READING

Dorsey, R.O., ed. *History and Pictures of St. Matthews*. Louisville, KY: 1968.

Ely, Carol. *Jewish Louisville: Portrait of a Community*. Louisville, KY: Butler Books, 2003.

Hill, Bob. *150 Years: The YMCA of Greater Louisville*. Louisville, KY: Bisig Impact Group, 2005.

Keys, Leslee F., ed. *Historic Jefferson County*. Louisville, KY: Jefferson County Historic Preservation and Archives, 1992.

Kleber, John E., ed. *Encyclopedia of Louisville*. Lexington, KY: University Press of Kentucky, 2001.

Ring, Al, *St. Matthews Firefighters: 84 Years of Firefighting in St. Matthews, Kentucky*. Louisville, KY: Butler Books, 2004.

ringbrothershistory.com/alsprojects/Waggener/Waggener.html

Shaw, Paula and Ann Russo. *Our Lady of Lourdes 1950–2000: From the Fifties to the Future*. Louisville, KY: Publisher Printing Company, 2000.

Simcoe, Richard O. *Simcoe Genealogy*. Charlotte, NC: self-published, 2010.

Thomas, Samuel W. *St. Matthews: The Crossroads of the Beargrass*. Louisville, KY: Butler Books, 1999.

Towles, Donald P. and David B. Whitaker, comps. and eds. *A History of Beargrass Christian Church, 1842–1992*. Louisville, KY: Beargrass Christian Church, 1992.

Discover Thousands of Local History Books
Featuring Millions of Vintage Images

Arcadia Publishing, the leading local history publisher in the United States, is committed to making history accessible and meaningful through publishing books that celebrate and preserve the heritage of America's people and places.

Find more books like this at
www.arcadiapublishing.com

Search for your hometown history, your old stomping grounds, and even your favorite sports team.